IMAGES
of America

EDMOND

OKLAHOMA

ALWAYS GROWING

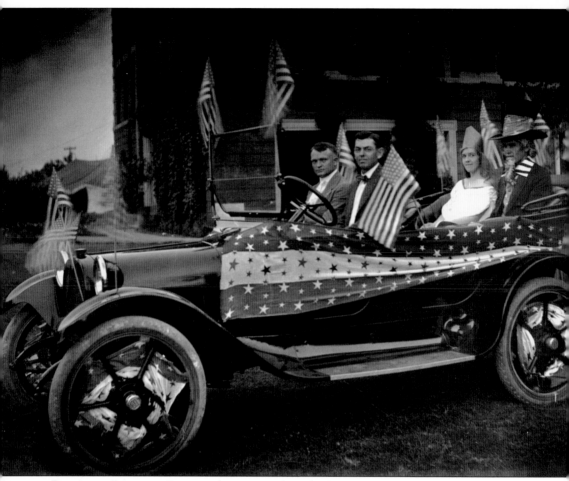

PATRIOTIC PARADES. Everyone loves a parade and Edmondites are no different. This photo was taken at a Fourth of July parade in 1917. The driver of the automobile is Central State Normal's Coach and Director of Physical Education Training, Charles Wantland. The other passengers are Professor Bill Howell, Ruby Potter (Lady Liberty), and Lee G. Gill (Uncle Sam). (Special Collections/Archives, University of Central Oklahoma Library.)

IMAGES
of America

EDMOND
OKLAHOMA
ALWAYS GROWING

Jan Mattingly

ARCADIA
PUBLISHING

Published by Arcadia Publishing
Charleston, South Carolina

Printed in the United States of America

Library of Congress Catalog Card Number: 2002103803

For all general information contact Arcadia Publishing at:
Telephone 843-853-2070
Fax 843-853-0044
E-mail sales@arcadiapublishing.com
For customer service and orders:
Toll-Free 1-888-313-2665

Visit us on the Internet at www.arcadiapublishing.com

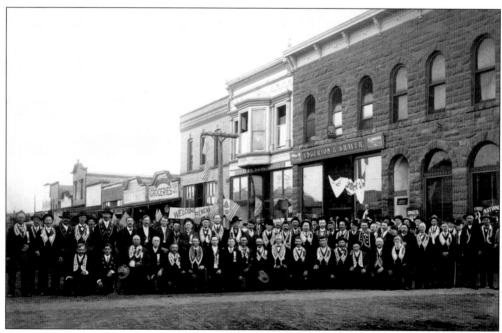

EDMOND LODGES. This photo was taken sometime before 1907. Several of Edmond's downtown stores are clearly visible. It is also apparent that Broadway had been smartly decorated with American flags. The men that assembled for this picture were members of the Oddfellows Lodge. Many prominent Edmond men joined this lodge, including G.H. Fink, Geo E. Paas, and Morey Baggerely. (Special Collections/Archives, University of Central Oklahoma Library.

CONTENTS

Acknowledgments 6

Introduction 7

1. 1886–1911 9

2. 1912–1937 33

3. 1938–1963 71

4. 1964–1989 101

5. 1990–2001 119

ACKNOWLEDGMENTS

Along the way in my research I met so many helpful individuals that were invaluable in the compilation of this book. There are several of these people, however, that I would be remiss in not thanking here. I would like to thank the staff of the University of Central Oklahoma's Special Collections/Archives Division, the work that you do is awesome. In particular, thank you Annette Ryan, without your knowledge and patience this book would have never been completed. To my former classmate, Nicole Willard, thank you for your professionalism and dedication. To Martha Hall at the Arcadian Inn Bed and Breakfast, thanks for so lovingly preserving the past. Also, thanks to Mayor Saundra Gragg Naifeh, Claudia Deakons, Carol Shanahan, Sherry Marshall, John Wilcox, and Marilyn Shewmaker. I also want to thank my family, particularly my mom, Amy Mattingly, for all her hard work and enthusiasm. Thanks also to my editor, Jeff Ruetsche. Tiffany, you know I could not have done this without your support and encouragement. Special thanks to Lucy Jeston Hampton, Emma Estill Harbour, Lucille Warrick, and Stan Hoig—you're all an inspiration to historians. In closing, this book is dedicated to my Uncle, Al Mattingly—you may be gone but you are never forgotten.

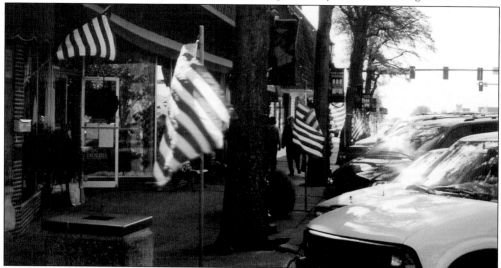

A NATION MOURNS. Tears and flags were a big part of Edmond after the tragedy of September 11, 2001. Residences and Downtown businesses proudly displayed the flag as the nation mourned. (Photograph by Author.).

INTRODUCTION

All cities share the common thread of rich histories brought to life by outstanding individuals. The City of Edmond is certainly no different. Edmond has a vibrant and exciting past that clearly unfolds as one views her many historical photographs.

Oklahoma's history is one of constant change and sacrifice, particularly by Native Americans who were forcibly moved to the area during the nineteenth century. The panhandle (No Man's Land) and the center of the territory (Unassigned Lands) were not allotted to any tribe and remained unsettled. Native Americans were promised the lands "as long as the grass grew and the waters ran"; that, however, was not to be. By 1884, Congress approved the Southern Kansas Railway Company's request to run a rail line south from Arkansas City, Kansas, through Indian Territory. Once the line was finished, the Santa Fe Railroad ran right through the middle of the Unassigned Lands. Mile Marker 103 (located within the Unassigned Lands) was a site along the railway that was to provide fuel and water for passing trains. A Santa Fe employee, John N. Steen, was assigned the duty of manning the pump house. Unbeknownst to Steen, he and his family were to become the first permanent residents of what would one day be the City of Edmond, a city that sprang to life overnight with the opening of the Unassigned Lands to settlement on April 22, 1889.

This is where we begin. This book spans the time frame of 1886 (Steen's arrival) to December of 2001. To residents of Edmond it is completely obvious why Governor Keating in 1994 called Edmond "a beacon for the rest of Oklahoma," but to those outside the area little is known of this wonderful city's history. In 1832, Washington Irving, "the Father of American Literature," camped in what was to be Edmond. The first church and public schoolhouse in Oklahoma Territory were built in Edmond. The *Edmond Evening Sun* is the state's oldest continuously running newspaper. Edmond's Normal School was the state's first institute of higher learning. Edmond rebounded from some of the most heinous tragedies that could befall a city in one year. Nineteen eighty-six saw tornadoes rip through the town, destroying and damaging many homes. That same year, postal worker Patrick Sherrill entered the Edmond Post Office and massacred 14 of his fellow employees. But thankfully, from tragedy sprang triumph with the crowning of Edmond's own Allison Brown as Miss Teen USA in 1986. Edmond resident Shannon Miller brought home two silver and three bronze medals at the 1992 Olympics, and then returned in 1996 to win two gold medals. In addition, Edmond can boast visits from former presidents Taft, Bush, and Clinton.

Throughout Edmond's history the population was always growing. Whether known as a railroad town or a college town, Edmond's residents both past and present simply know Edmond as the perfect town. This fact becomes apparent as one sorts through the thousands of historical photographs that were lovingly preserved for us to enjoy today.

Bibliography

Crowder, Dr. James L. *Historic Edmond, an Illustrated History*. San Antonio, TX: Historical Publishing Network, published for the Edmond Historical Society, 2001.

The *Edmond Sun*, July 18,1889–present. Under titles of The *Edmond Sun*, *Edmond Oklahoma Sun*, *Edmond Democrat*, *Edmond Sun-Democrat*, and *Edmond Evening Sun*.

Fordice, Stella B. *History of Edmond, Oklahoma*. University of Oklahoma, Master of Arts Thesis, 1927.

Hoig, Stan. *Edmond, the First Century*. Norman, OK: University of Oklahoma Press, published for the Edmond Historic Preservation Trust, 1987.

Jones, Edna. *Sixty Years at Central, Facts and Figures of Service and Friendship Through the Years 1891–1951*. Edmond, OK: Central State College, 1951.

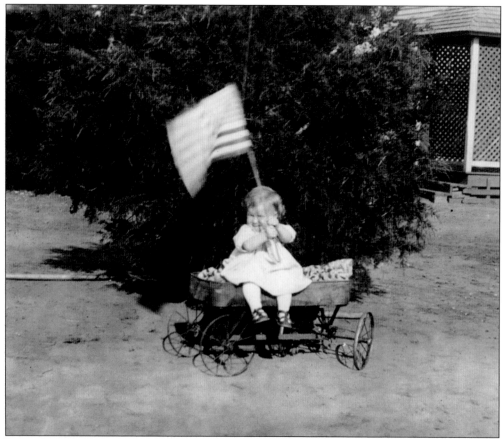

LITTLE PATRIOT. This unidentified girl proudly displays her flag and wagon. Throughout Edmond's history, Fourth of July parades and festivities have been eagerly anticipated. (Frankie Myall Collection, Special Collections/Archives, University of Central Oklahoma Library.)

One

1886–1912

The opening of the Unassigned Lands by run assured the rapid short-term growth of Edmond, Oklahoma Territory, but the long-term growth was solely dependent on the fortitude of the town's citizens. Edmond's first stabilizing force was the railroad, but the opening of the Territorial Normal School in 1891 would eventually prove to be the glue that held the town together. Edmond's population would start out at three in 1886 and rise to almost two thousand by 1911.

The first 25 years of Edmond's history illustrate the typical attempts to etch out a city from almost nothing. Some businesses flourished while others failed, people came and people went, and community organizations banded and disbanded. But through all the change, the City of Edmond began to take shape.

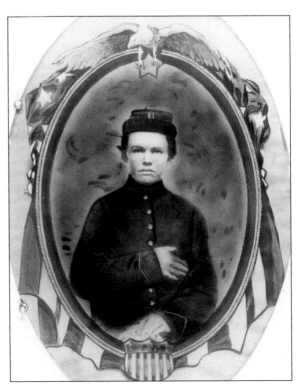

FUTURE EDMONDITE. This is a picture of Territorial Normal School's first president, Richard Thatcher, many years before his fateful journey to Edmond. During the Civil War, a 15-year-old Thatcher enlisted in the 111th Illinois Infantry as a drummer boy. There he gained a certain amount of notoriety by escaping from a Confederate prison in October of 1864. (Ann Davis Collection, Special Collections/ Archives, University of Central Oklahoma Library.)

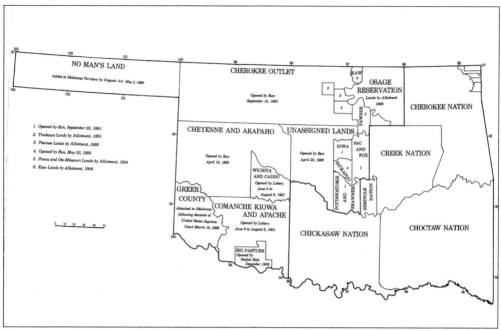

OKLAHOMA. This is a map of Indian Territory around the time of the initial land opening in 1889. The name Oklahoma comes from the Choctaw words "okla" (meaning people) and "humma" (meaning red). Oklahoma is bordered by six states: Texas to the south and west, Arkansas and Missouri to the east, Kansas to the north, and Colorado and New Mexico at the tip of the northwestern Oklahoma panhandle. (Morris, Goins & McReynolds, Historical Atlas of Oklahoma, Second Edition, University of Oklahoma Press.)

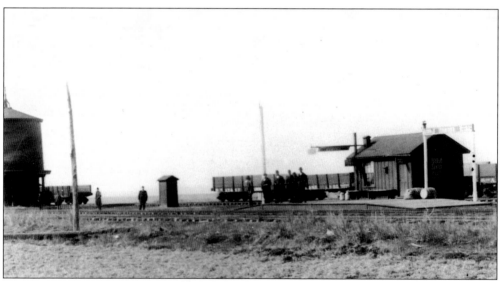

RAILROAD. In 1884, Congress approved the Southern Kansas Railway Company's request to run a north-south line from Arkansas City, Kansas, to Gainesville, Texas. Southern Kansas Railway was actually a part of the Atchison, Topeka & Santa Fe Railroad Company. The railroad was completed in 1887, and Oklahoma's future was forever changed. (Archives and Manuscripts Division of the Oklahoma Historical Society.)

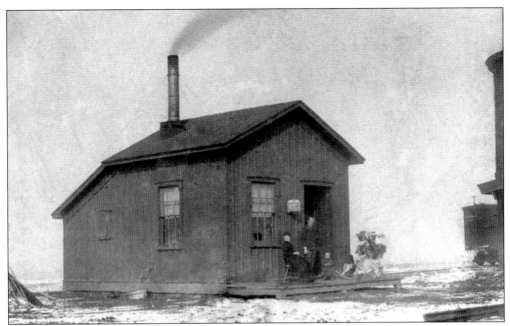

NEW HOME. Mrs. Cordelia Steen, John N. Steen (standing), and baby Charles J. Steen take in the weather on December 25, 1888. John Steen came to Edmond in December of 1886 to supervise the digging, construction, and operation of the Santa Fe Railway's well and water system—giving him the distinction of being Edmond's first permanent resident. (Special Collections/Archives, University of Central Oklahoma Library.)

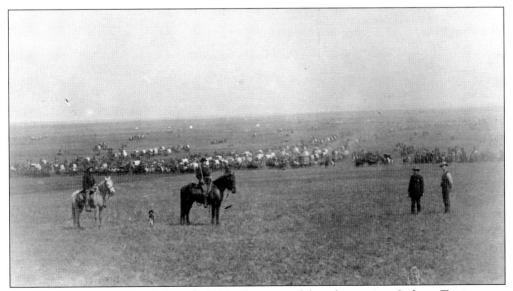

LAND RUN. Between 1885 and 1888 Congress debated opening Indian Territory to homesteaders. Those for the opening prevailed and the western part of the territory was opened to settlers through a total of six land runs between 1889 and 1895. This photograph shows people lining up for the first run held on April 22, 1889. Thousands dashed toward a new life when the signal to run was finally given at noon. (Archives and Manuscripts Division of the Oklahoma Historical Society.)

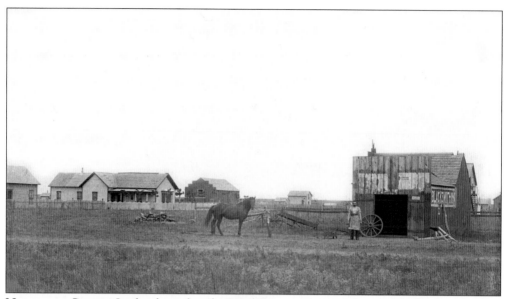

NECESSARY GOODS. In the days after the Land Run a very necessary commodity was lumber. James L. Brown capitalized on this need by establishing a lumberyard on April 25, 1889. (Special Collections/Archives, University of Central Oklahoma Library.)

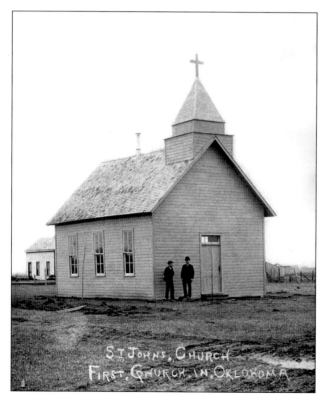

FIRST CHURCH. The first church built in Oklahoma Territory was St. John's, located at the corner of Boulevard and First Street. Father Nicholas Scallan sought the assistance of four Catholic men—J.J. Kerwin, J.C. Canty, Michael O'Keefe, and James Brown—to build the church. The first mass was held on June 24, 1889. (Special Collections/Archives, University of Central Oklahoma Library.)

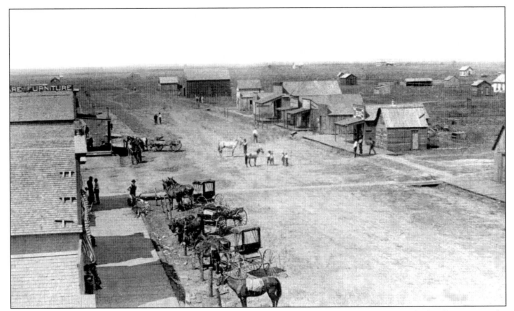

BUSINESS DISTRICT. This is an 1890 view of Broad Street (Broadway) looking north. Edmondites could visit downtown to take care of most household needs. Downtown stores included S.W. Johnson Dry Goods, Farwell & Moore Drugs, Tullis & Edgerton General Supply, and the Bank of Edmond, John Pfaff President; also, if you got hungry and had 25¢ left in your pocket, you could eat at R. Galbreath's Restaurant. (Special Collections/Archives, University of Central Oklahoma Library.)

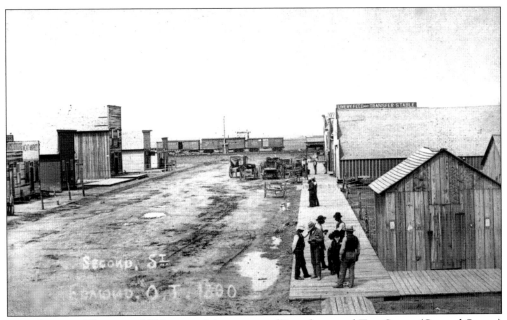

TWO STREET. This is an 1890 view of the corner of Broadway and Two Street (Second Street) looking west. Edmond's five hundred residents at one time or another paid a visit to the livery stable owned by James Taylor and Frank Dawson. (Special Collections/Archives, University of Central Oklahoma Library.)

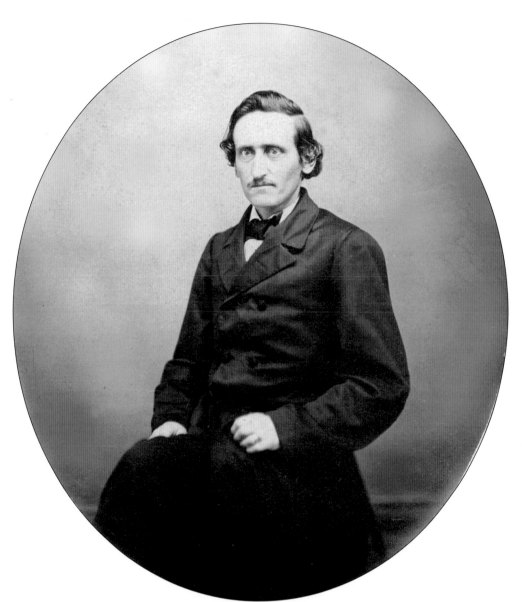

FAMOUS EDMONDITE. Milton W. "Kickingbird" Reynolds left a lasting legacy on the fledgling City of Edmond. Reynolds was born in Michigan and went on to serve in the Nebraska and Kansas legislatures. He participated in the Land Run, hoping to settle in Guthrie, Oklahoma, but opted instead for Edmond. He went on to found the *Edmond Sun*, which is Oklahoma's oldest continuously running newspaper. Legend states that as a reporter Reynolds covered the signing of the 1867 Treaty of Medicine Lodge, and while doing so was attacked by the Southern Cheyenne Chief, Black Kettle. The Kiowa Chieftain Kickingbird took pity on poor Reynolds and saved him from Black Kettle's tomahawk. Reynolds and Kickingbird became friends, and upon the chieftain's death, Reynolds took on his name for literary purposes. The more likely scenario is that Reynolds simply reported on the signing of the treaty, met Kickingbird, liked his name and decided to use it as the signature for his editorials. Reynolds died August 9, 1890. He is buried in Edmond's Gracelawn Cemetery. (Special Collections/Archives, University of Central Oklahoma Library.)

14

ANTON CLASSEN. Classen, a lawyer, came to Edmond after the Land Run and opened a law office in the same building as the *Edmond Sun*. This close proximity might account for his filling the void as the Sun's editor after Milton Reynolds' death. He is also noteworthy for his generous donation of 40 acres of land for the Normal School. Classen eventually moved to Oklahoma City and left his mark as a real-estate developer. (Special Collections/Archives, University of Central Oklahoma Library.)

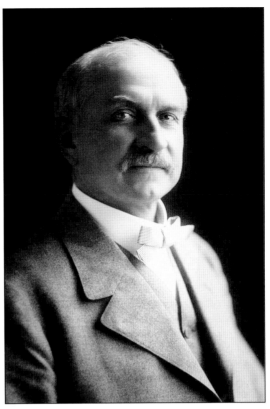

EARLY HOMESTEADS. This is an 1889 view looking east from Broad Street. The building to the far left in the background is St. John's. The house just to the right of the church is Anton Classen's rather small house. Classen's neighbor to the right was Milton Reynolds. The building in the back and to the far right was the first public schoolhouse built in Oklahoma Territory. (Special Collections/Archives, University of Central Oklahoma Library.)

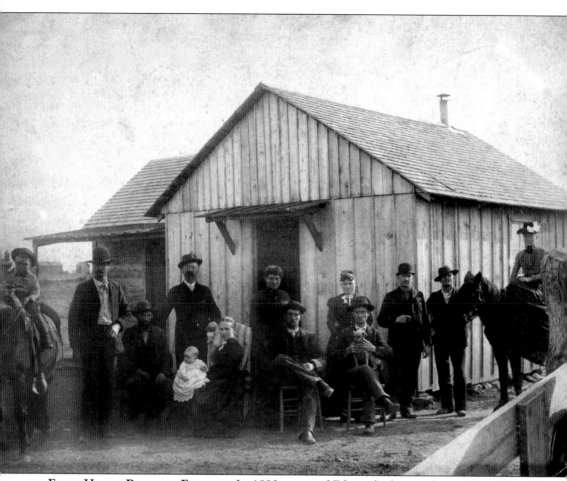

FIRST HOUSE BUILT IN EDMOND. In 1890, some of Edmond's first settlers gathered for this photograph. From left to right: Charles J. Steen (horseback); George B. Elliott, who established his homestead on the southeast corner of Fifteenth and Kelly; Joseph D. "Dee" Turner, who purchased a claim at the northwest corner of Second and Kelly; Colonel Eddy B. Townsend, who graciously provided his porch for this photograph, became Edmond's first settler by winning the claim located at the quarter section west of Boulevard and south of Second Street; Mrs. J.D. Turner with baby; J.H. Turner; Mrs. Hardy C. Anglea; Hardy Cryer "Pete" Anglea, who staked claim at the northwest corner of Fifteenth and Boulevard; Mrs. John N. (Cordelia) Steen; John N. Steen; Robert B. Farwell, who established Edmond's first drugstore; John Wheeler Turner (brother of J.H. Turner), who homesteaded on the quarter section of the northeast corner of Fifteenth Street and Kelly; and Miss Florence Higbee (horseback), who served as the first organist for the early Edmond Union Sunday School. (Special Collections/Archives, University of Central Oklahoma Library.)

16

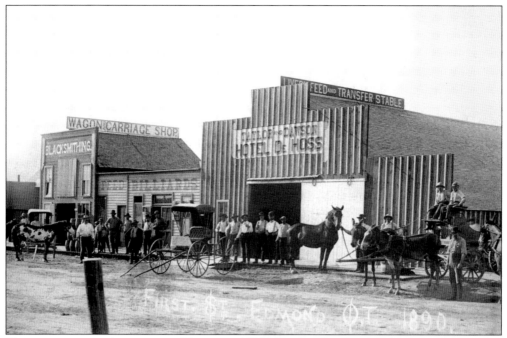

TRANSPORTATION ASSISTANCE. This is an 1890 photograph of several businesses along Two Street. The building on the far right is the Edmond Blacksmith and Wagon Shop. The Eades Brothers ran the shop. The building on the right is either the Taylor and Dawson Livery Stable or the Hotel De Hoss. Sandwiched between the two is the Billiards Hall. (Special Collections/Archives, University of Central Oklahoma Library.)

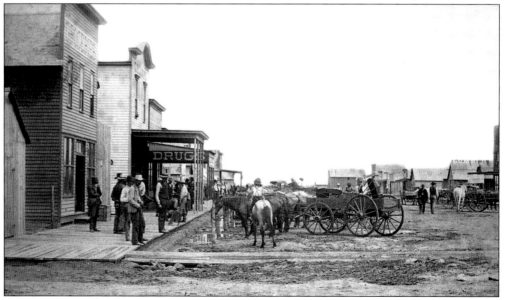

BROADWAY, 1890. Just one year after the "Run of '89," downtown Edmond, Oklahoma Territory, was growing. This picture was taken facing north. The first tall building on the left was the Lott & Bowman Grocery. Also visible is the Moore & Howard Drugstore. (Special Collections/Archives, University of Central Oklahoma Library.)

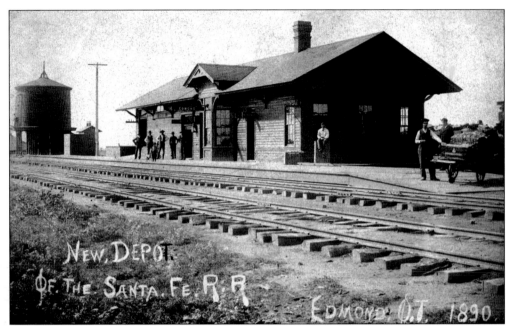

New Depot. Santa Fe Railroad Mile Marker 103 would one day become the City of Edmond. The site was to provide water and fuel for passing trains. After the Land Run of 1889, Edmond began to take shape and a new depot was required. This 1890 picture shows the new "modern" Edmond Depot. (Special Collections/Archives, University of Central Oklahoma Library.)

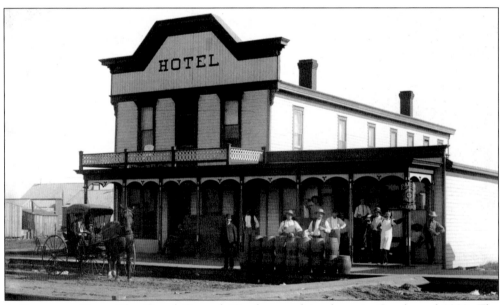

A Place to Stay. The Grand Central Hotel opened its doors in October of 1889. The proprietors were the Eades Brothers. Ownership changed hands in 1890 to J.R. Smith, who ran the hotel until M.D. Thatcher took over. The progressive new owner was actually Mrs. Richard Thatcher. One of her first changes was to close the hotel's bar. With that done, she comfortably touted the hotel as "first class." (Special Collections/Archives, University of Central Oklahoma Library.)

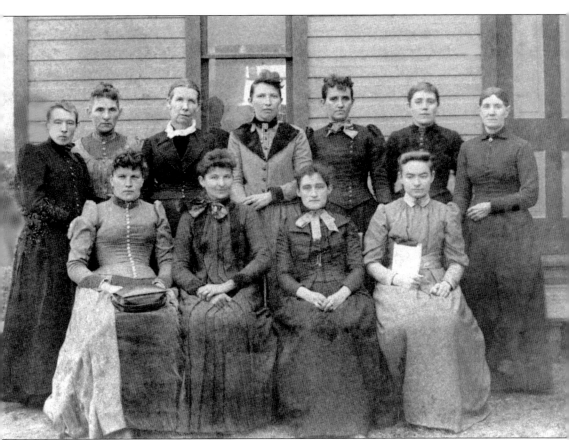

LADIES' AID SOCIETY. This is an 1889 photograph of one of Edmond's first civic organizations, the interdenominational Ladies' Aid Society. Their major accomplishment was coming up with the funds to build the first public schoolhouse in Oklahoma Territory. Members are pictured, from left to right, as follows: (front row) Mrs. Wahl, Mrs. Drake, Mrs. Forster, and Mrs. Joseph Duwosky; (back row) Mrs. Errisman, Mrs. Moose, Mrs. Wilderson, Mrs. Cathers, Mrs. Baker, Mrs. Ricketts, and Mrs. Peck. The school still stands on Second Street. (Courtesy of Lucille Warrick and Janie Bates, Special Collections/Archives, University of Central Oklahoma Library.)

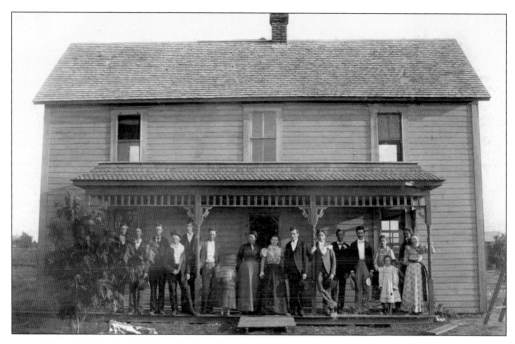

HUFFMAN HOUSE. Oklahoma's first institute of higher learning held its initial class on November 9, 1891, in the newly constructed Methodist Episcopal Building at Broadway and Hurd. The Territorial Normal School consisted of 23 students who eagerly awaited the completion of their two-year teacher certificate program. By the time the actual school building opened on January 13, 1893, attendance had risen to 80 students. By the time these pictures were taken, Normal School's student body was rapidly approaching two hundred. The Huffman House helped with the influx of would-be teachers by opening a rooming house that catered to these students. (Special Collections/Archives, University of Central Oklahoma Library.)

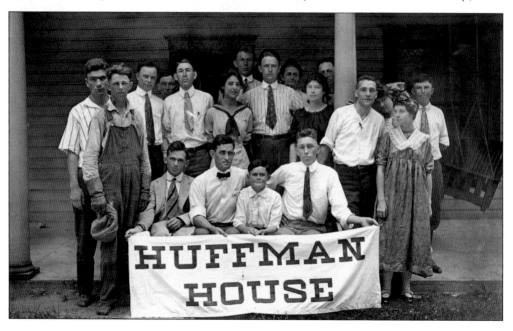

TERRITORIAL SCHOOL. The Territorial Normal School received some additions in 1894 with the construction of "wings" to the building. The Edmond Sun raved that the school was "the Gem of Oklahoma…a magnificent structure, equipped with modern improvements…where students will find the purest of water, a healthy location, the best of society, and homelike surroundings." (Special Collections/Archives, University of Central Oklahoma Library.)

NORMAL'S FIRST PRESIDENT. Richard Thatcher accepted the job as Normal School's first president and moved to Edmond in 1891. After his two-year term as president, he remained at the school as the Professor of Mathematics and Astronomy. He died in 1909 at the age of 63. (Special Collections/Archives, University of Central Oklahoma Library.)

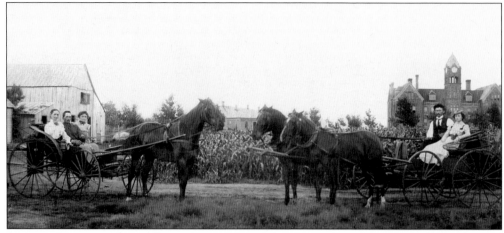

SUNDAY DRIVERS. This well-posed 1899 picture has two Edmond families proudly showing off their horses and buggies. The Normal School can clearly be seen in the distance. The occupants of the buggy to the left are Mr. and Mrs. Huffman and sister. The buggy to the right contains Mr. and Mrs. Rahmann. (Special Collections/Archives, University of Central Oklahoma Library.)

STARTING COLLEGE. After a few years of operation, the Territorial Normal School became known as Central Normal School (CNS). Its school motto: "Do the best you can every day." This is a picture of the president's office where one would have enrolled for classes at Central between 1893 and 1901. (Special Collections/Archives, University of Central Oklahoma Library.)

22

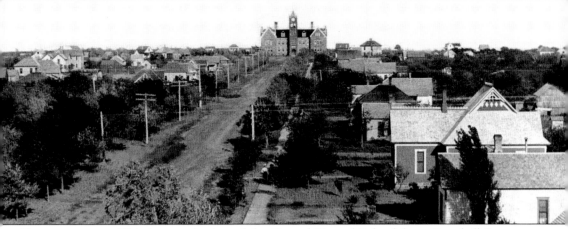

EDMOND GROWS. This is an early view of the Central Normal School from Campbell Street, *c.* 1900. The well kept houses attest to Edmond's growing sense of community pride. At the turn of the century Edmond's population was close to one thousand. (Special Collections/Archives, University of Central Oklahoma Library.)

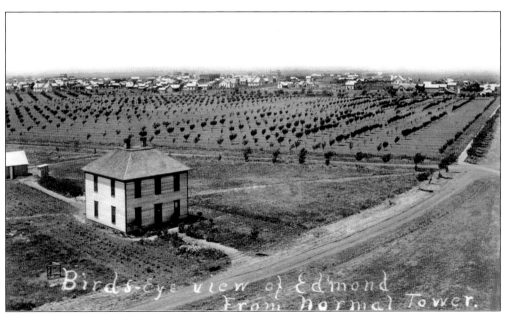

NICE VIEW. This photograph was taken around 1900. It is another view from CNS—this time from inside the tower. The house and orchard belonged to Anton Classen. The growth surrounding downtown is apparent in the background. (William Ralston Williams Collection, Special Collections/Archives, University of Central Oklahoma Library.)

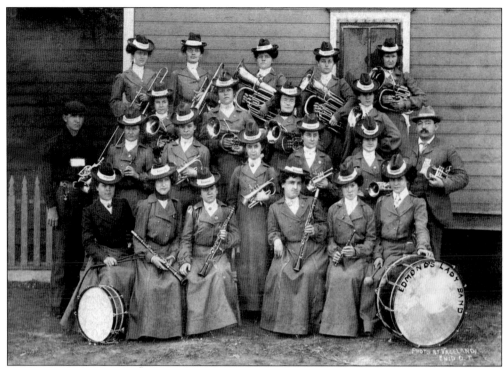

EDMOND BAND. This is a picture of the Edmond Ladies Band. The photograph was taken during a September 1902 performance in Enid, Oklahoma Territory. The band proudly displays their new uniforms, purchased at a cost of $8.00 each. The photograph was donated to the University of Central Oklahoma for Blanche Coffey Specht (top row fourth from the left). (Blanch Evelyn Specht Collection, Special Collections/Archives, University of Central Oklahoma Library.)

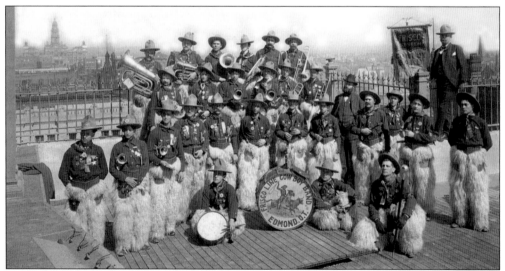

PLAY ON. Not to be outdone by the women, the men formed a band, too. This is the Frisco Line Cowboy Band in 1902. The band is smartly attired in chaps and Stetsons. The group performed as far away as Des Moines, Iowa, but is shown here during a stop at Fort Worth, Texas. (Special Collections/Archives, University of Central Oklahoma Library.)

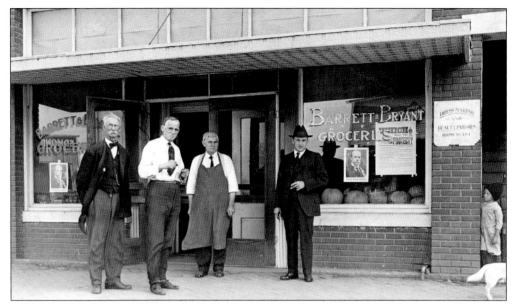

BARRETT AND BRYANT GROCERY. The 1905 advertisements for the Barrett and Bryant Groceries included the store's motto: "Good, Fresh, Clean Groceries." If one was lucky enough to have a phone you could ring them at 58. W.B. Bryant (second from the left) was one of the owners. The little boy to the far right wrongfully believed he was well hidden from the camera's range. (Special Collections/Archives, University of Central Oklahoma Library.)

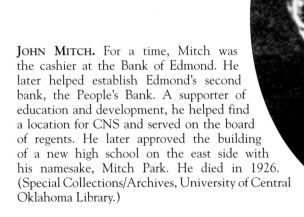

JOHN MITCH. For a time, Mitch was the cashier at the Bank of Edmond. He later helped establish Edmond's second bank, the People's Bank. A supporter of education and development, he helped find a location for CNS and served on the board of regents. He later approved the building of a new high school on the east side with his namesake, Mitch Park. He died in 1926. (Special Collections/Archives, University of Central Oklahoma Library.)

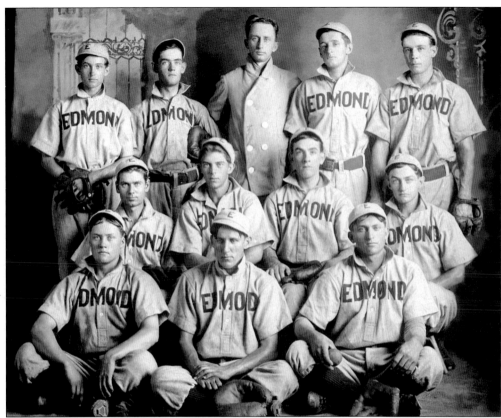

AMERICA'S PASTIME. Americans have always enjoyed the game of baseball and no town would be complete without its own team. Central organized their first baseball team in 1896. By 1897, one could cheer them on with the schools first yell: "Karo, Karo, Kire, Kee, Oklahoma Normal, Don't You See, Hip, Hip, Who, Bronze and Blue, Oklahoma Normal, Hoo! Hoo! Hoo!" Pictured above is the 1904 Central baseball team. (Special Collections/Archives, University of Central Oklahoma Library.)

CAMPUS ROOMS. This is a 1908 picture of the library at CNS. By this time, Central had two major buildings. The original building was called the "North Building," and the newer building was appropriately called the "South Building." The South Building was used for administrative purposes as well as for classrooms. The library was located in the "South Building." (Special Collections/Archives, University of Central Oklahoma Library.)

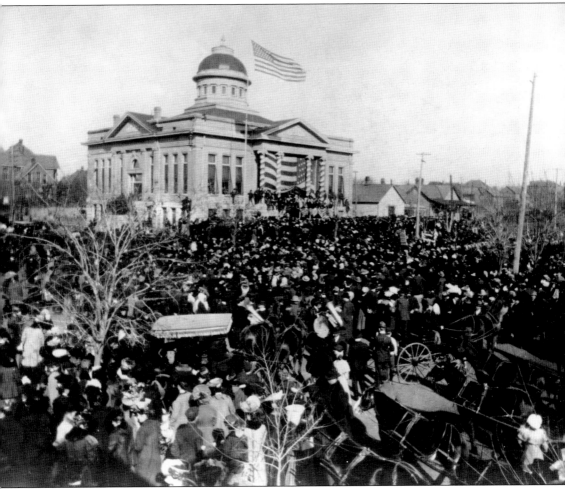

STATEHOOD! Indian Territory and Oklahoma Territory joined to become the State of Oklahoma on November 16, 1907. Many Edmond residents traveled to the capital in Guthrie to witness the Statehood Ceremony at the Carnegie Library. Guthrie was packed with an estimated 25,000 celebrating Oklahomans. Applause rang out when it was announced at 9:20 a.m. that President Theodore Roosevelt had signed the proclamation making Oklahoma a state four minutes earlier. During the ceremony, a symbolic marriage took place between Miss Indian Territory and Mr. Oklahoma Territory. Americans could now proudly wave a new 46-star flag. (Special Collections/Archives, University of Central Oklahoma Library.)

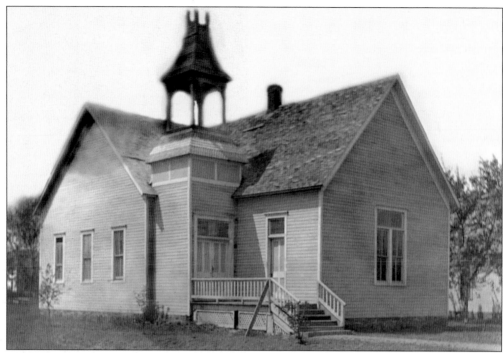

BAPTIST CHURCH. Edmond's first Baptist church was built in 1894. The major force behind completion of the church was the enthusiastic pastor, W.N. Nichols. The church was the largest in town and could accommodate approximately two hundred worshippers. (Nell Pauly Wheatley Collection, Special Collections/Archives, University of Central Oklahoma Library.)

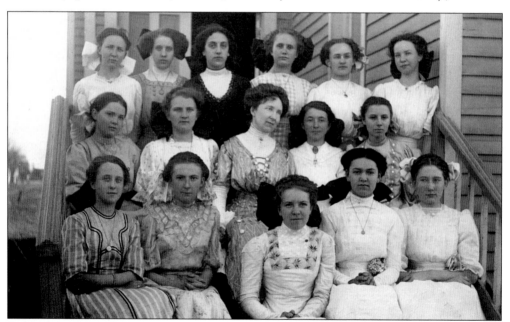

SUNDAY SCHOOL. The new Baptist church was located at the corner of Littler and Main. The Young Ladies' Sunday school group gathered on the front steps of the church and posed for this picture in 1909. (Special Collections/Archives, University of Central Oklahoma Library.)

EARLY EDMONDITE. Colonel Henry H. Moose participated in the Land Run of 1889, and staked a claim in Guthrie, Oklahoma Territory. He came to Edmond in September of that year as Edmond's second pioneer public school teacher. Moose was elected city clerk an impressive 12 times from 1891 to 1907. He also founded Edmond's first Masonic Lodge. (Special Collections/ Archives, University of Central Oklahoma Library.)

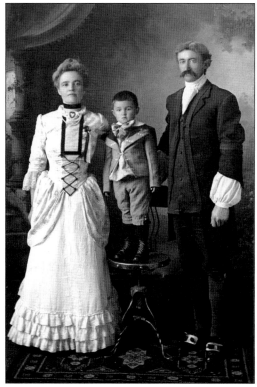

KEEPING IN TOUCH. This is a photograph of an Edmond family, *c.* 1910. Pictured from left to right are Anna Biggs with her son LaVern and her husband, Dr. Geo Camp. LaVern went on to become an instructor in the School of Engineering at the University of Oklahoma in Norman. (Special Collections/Archives, University of Central Oklahoma Library.)

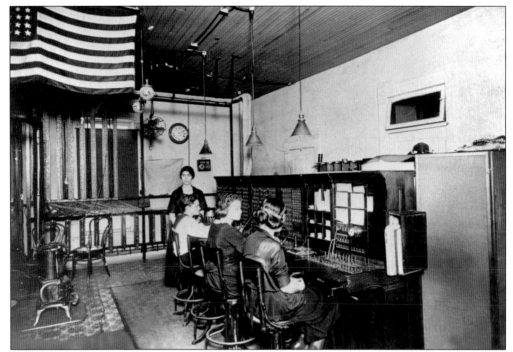

MODERN COMMUNICATION. Edmond's first telephone system was operational by 1902. As Edmond grew the need for telephones grew as well. Shown here is the Edmond Telephone Exchange, located above the Citizen's National Bank. The Chief Operator, Pearle Bryan, stands watch over the other operators. Bryan worked at the Telephone Exchange for 25 years. (Betty Burt Collection, Special Collections/Archives, University of Central Oklahoma Library.)

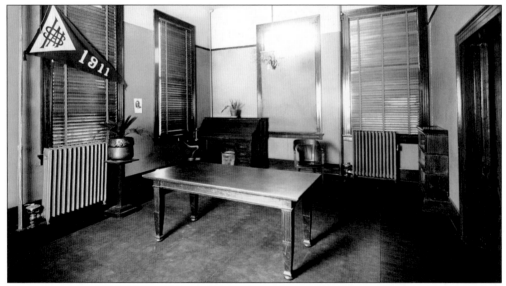

NEW NAME. By 1909, Central Normal School was being called Central State Normal School (CSNS) or just Central State for short. This 1911 photograph shows the interior of a campus office. At that time, the school's motto was, "Don't let your studies interfere with your education." (Special Collections/Archives, University of Central Oklahoma Library.)

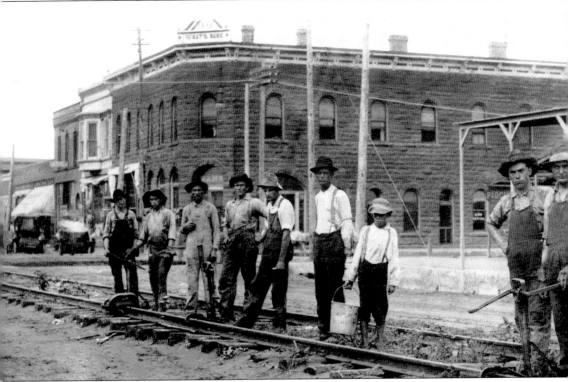

NEW TRANSPORTATION. Anton Classen continued to contribute to Edmond's growth by joining with the Oklahoma Railway Company in 1910. The team requested a way to form a thoroughfare between Edmond and Oklahoma City. The proposal was for an Interurban that would run through Edmond south of Second Street and north of Broadway to Main. Once the proposal was agreed upon, construction began immediately. Workers laying track for the Interurban take a short break to pose for this 1911 photograph. The large building in the background was the People's Bank of Edmond, which had by this time merged with the Bank of Edmond to become the First National Bank of Edmond. (Neal Little Collection, Special Collections/Archives, University of Central Oklahoma Library.)

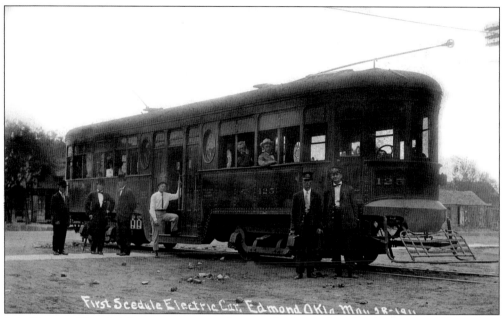

First Scedule Electric Car, Edmond Okla Mau 18-1911

IT'S FINALLY HERE! After many starts and stops, the Interurban finally came to Edmond on May 29, 1911. Edmond citizens got the opportunity to check out the first electric car a day before the formal opening. Progress and development would continue to define the growth of Edmond. (Linda Jones Collection, Special Collections/Archives, University of Central Oklahoma Library.)

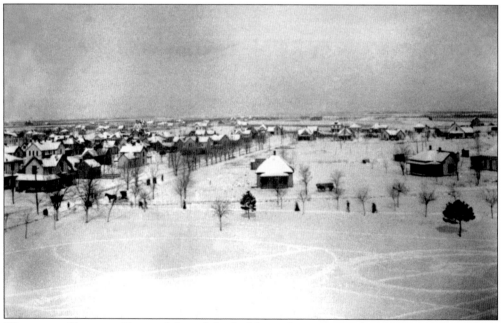

WINTER IN EDMOND. Pioneer life and the building of a new town had its share of hardships, but Edmondites held tough even through several harsh winters early in the city's history. This is a winter view of Edmond houses taken from the Old North Tower. (Special Collections/Archives, University of Central Oklahoma Library.)

Two

1912–1937

Edmond continued to grow during the next 25 year period, 1912–1937. Community beautification projects became the town focus. Red-rock, brick, and white-frame buildings replaced hastily built structures. This era saw the emergence in Edmond of street lamps, paved roads, college degrees, a golf club, a theatre, Highways 66 and 77, a new high school, a grand college athletic program, and a trend toward historical preservation—among other things. By 1937, Edmond's population had grown to almost four thousand.

But national as well as international events also dictated the mood in Edmond. Automobiles continued to gain popularity, along with the Ku Klux Klan. Prohibition ended the legal consumption of alcohol, and the outbreak of World War I sent Edmond sons off to fight a war on foreign soil. The Great Depression and the Dust Bowl compounded the harshness of the times, but also proved the resilience and determination of Edmond's citizens.

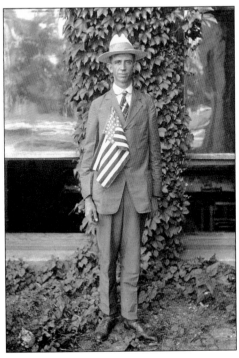

THE GREAT WAR. Edmondites responded in many different ways to America's entry into World War I. But the unanimous response was a renewed and stronger sense of patriotism. Ed Crabb, a soldier in the Student Army Training Corps, poses with his flag in 1917. (Special Collections/Archives, University of Central Oklahoma Library.)

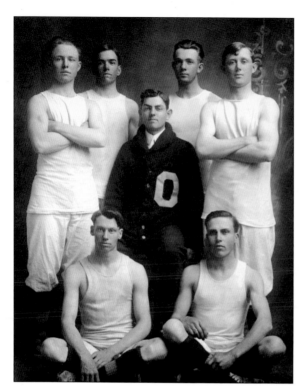

BASKETBALL TEAM. Central's athletic department took a massive turn for the better with the inclusion of Charles Wantland (center) to the teaching staff in 1912. The teammates surround their coach, from left to right, as follows: (front row, sitting) Dalton Herrin and Birney Herrin; (back row, standing) Geo Perdue, Volney Hamilton, Max Chambers, and Tom Rogers. Team captain Chambers would return to Central in 1949 as president of his alma mater. (Nell Pauly Wheatley Collection, Special Collections/ Archives, University of Central Oklahoma Library.)

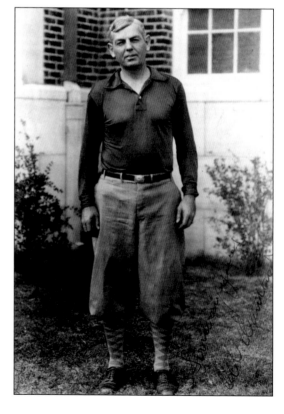

NEW COACH. Charles Wantland graduated from Purcell High School in 1906, and attended the University of Oklahoma, graduating in 1910. Throughout his school years, he was a noteworthy athlete who was a four-time letterman in college. He was an all-star football and basketball player, and even received the all-around medal for track work. UCO's Wantland Stadium honors the memory of his remarkable career at Central. (Special Collections/Archives, University of Central Oklahoma Library.)

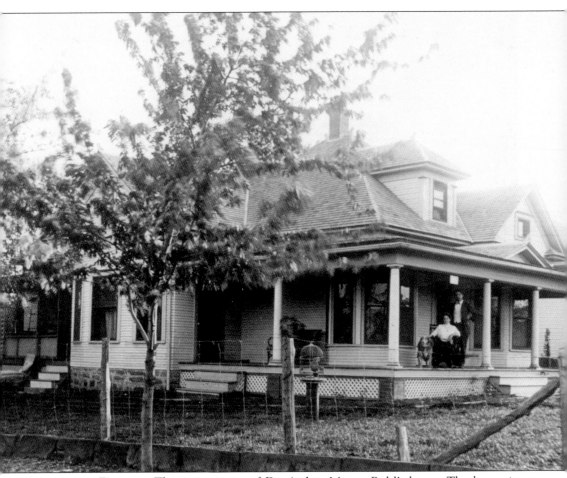

TERRITORIAL DOCTOR. This is a picture of Dr. Arthur Master Ruhl's home. The house is located at 328 East First. Dr. Ruhl, his wife Edith and their dog Marke are pictured on their porch in 1912 (the parrot's name is unknown). The Ruhl's came to Edmond in 1895 from Logan County and Arthur married Edith Snyder in 1901. Dr. Ruhl was one of Edmond's first physicians and surgeons. He was also Central's team physician. The land the house was built on was deeded to Edith in 1907, and construction began in 1910. The Ruhl's welcomed their child, Floranna, into the world in 1911. Dr. Ruhl died in 1936. Hundreds attended his funeral and businesses shut down in his honor. Edith Ruhl outlived her husband by 43 years. Over time, the home naturally began to deteriorate. Fortunately, it was purchased in 1989 by Gary and Martha Hall, who returned the home to its original splendor. The beautiful house is now known as the Arcadian Inn Bed and Breakfast. (Gary and Martha Hall Collection at the Arcadian Inn Bed & Breakfast.)

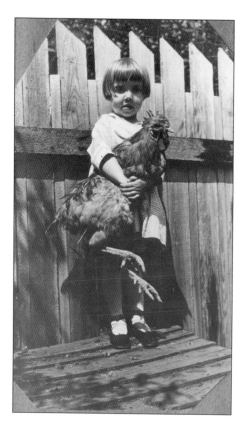

FAMILY SCRAPBOOK. A three-year-old Floranna Ruhl is pictured above with a reluctant "pet" chicken. Floranna lovingly kept a scrapbook of her youthful years. Her dedication proved a valuable link to what it must have been like to grow up in Edmond shortly after the turn of the century. (Gary and Martha Hall Collection at the Arcadian Inn Bed & Breakfast.)

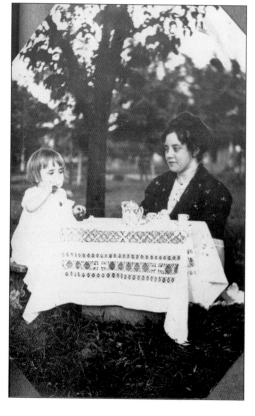

TEA PARTY. Floranna Ruhl and her mother, Edith, enjoy an afternoon tea party, c. 1914. Dr. Ruhl also participated, although he is not pictured here. Floranna's parents adored their little girl, as evidenced by the pictures they took. (Gary and Martha Hall Collection at the Arcadian Inn Bed & Breakfast.)

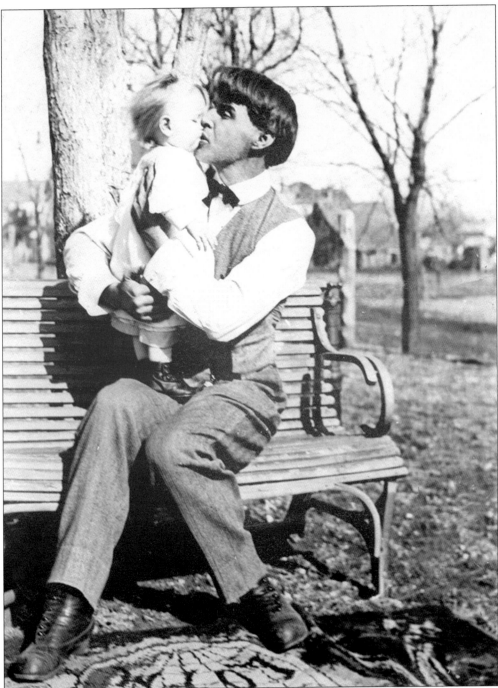

DR. ARTHUR M. RUHL AND BABY FLORANNA IN 1912. Dr. Ruhl to his daughter, November 23, 1927: "My Dear Daughter, You can do as much as you think you can, but you'll never accomplish more; if you're afraid of yourself, young lady, there's little for you in store. For failure comes from the inside first, it's there if you only knew it, and you can win, though you face the worst, if you feel that you are going to do it." (Gary and Martha Hall Collection at the Arcadian Inn Bed & Breakfast.)

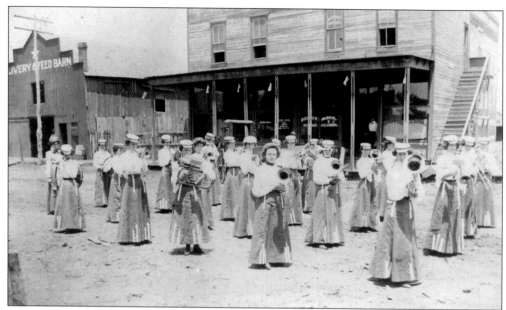

DOWNTOWN OFFICE. This is an image of the Edmond Ladies Band parading downtown, *c.* 1912. Dr. Ruhl's office at 121 First Street can clearly be seen in the background. The doctor can also been seen standing in the doorway, enjoying the show. (Archives and Manuscripts Division of the Oklahoma Historical Society.)

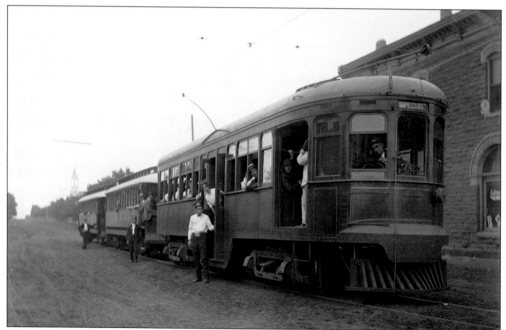

A NEW WAY TO TRAVEL. The coming of the Interurban marked a milestone in the development of Edmond. This Interurban picture was taken in 1914. By that time, the Interurban had modernized into three cars with a porter at each door. The passengers seem to know their picture is being taken as they look out from the windows. (Special Collections/ Archives, University of Central Oklahoma Library.)

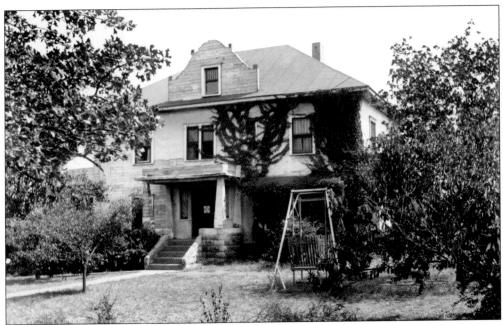

EDMOND HOMES. This is a photograph of the Dickerson home. It gives us a glance into one of the house styles after the turn of the century. The picture is also unique because it was the first photograph taken by Central's photography class on August 4, 1913. Central was the first state school in Oklahoma to initiate a real photography "class." (Special Collections/Archives, University of Central Oklahoma Library.)

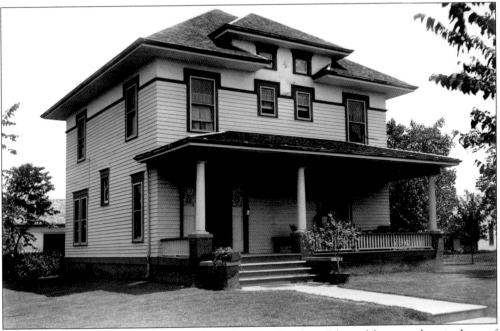

MORE EDMOND HOMES. This is another photograph of an Edmond home, taken in June of 1915. The owners were the Farrars. (Special Collections/Archives, University of Central Oklahoma Library.)

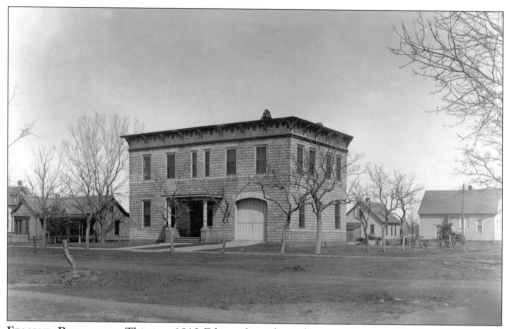

EDMOND BUILDINGS. This is a 1913 Edmond residential scene. You can clearly see houses to the left and in the background. The centerpiece of the photograph, however, is City Hall. The tank on wheels was probably a fire truck. (Special Collections/Archives, University of Central Oklahoma Library.)

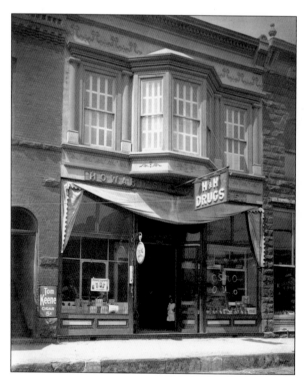

HOWARD'S DRUG STORE. Dr. J. W. Howard opened a drug store around the turn of the century. He appropriately called it Howard's Drug Store. Everett Hiatt bought the store in 1907, and ran it himself until 1911, when Dr. Howard's nephew, Ivan Howard, bought interest in the store. It was then called H & H Drugs. By 1914, Everett Hiatt left Edmond and the store again became Howard's Drug Store. (Special Collections/ Archives, University of Central Oklahoma Library.)

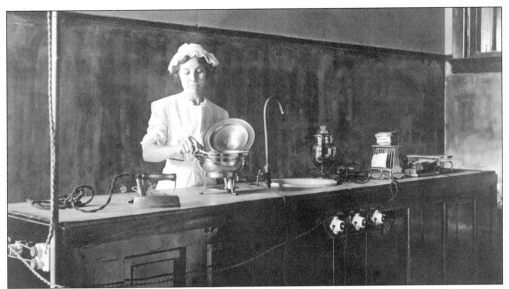

COLLEGE CLASSROOM. This is a picture of the cooking classroom at Central. On December 29, 1919, the name officially changed to Central State Teachers College (CSTC). The school was now a four-year institution with the advantage of granting B.A. and B.S. degrees rather than certificates to graduating students. (Special Collections/Archives, University of Central Oklahoma Library.)

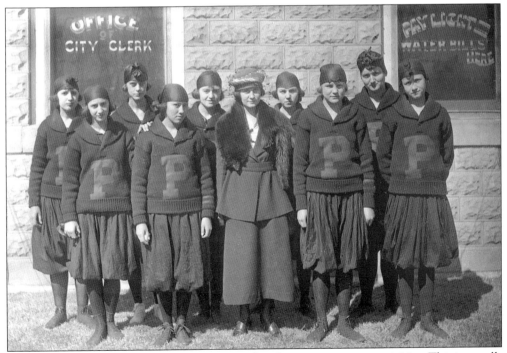

GIRL'S TEAM. Many women formed teams and took part in sporting activities. This is a well-posed picture of the Ponca City women's basketball team on a visit to Edmond, in front of City Hall. A friendly reminder to "Pay Your Light and Water Bill" can be seen in the background. (Special Collections/Archives, University of Central Oklahoma Library.)

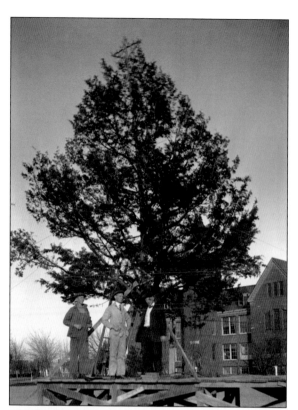

CHRISTMAS IN EDMOND. This picture represents Edmond's first publicly displayed Christmas tree. The immense cut tree was prominently exhibited on a wooden scaffold in front of the Old North Tower in December of 1915. If you look closely you can see the star that was somehow placed atop the tree. (Special Collections/ Archives, University of Central Oklahoma Library.)

PAY IT NOW. This is a 1915 photograph of the beverage counter at an Edmond drug store (probably Howard's). Welch's seems to have a monopoly on beverage choices, and if you wanted a drink, credit did not seem to be a payment option. (Linda Jones Collection, Special Collections/ Archives, University of Central Oklahoma Library.)

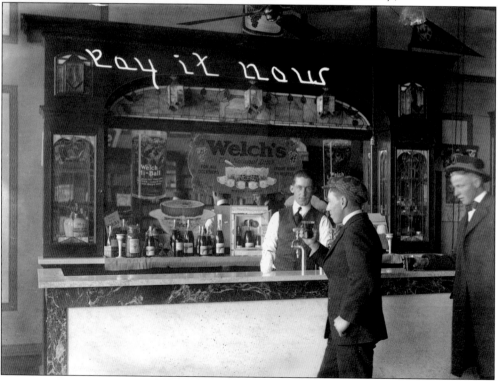

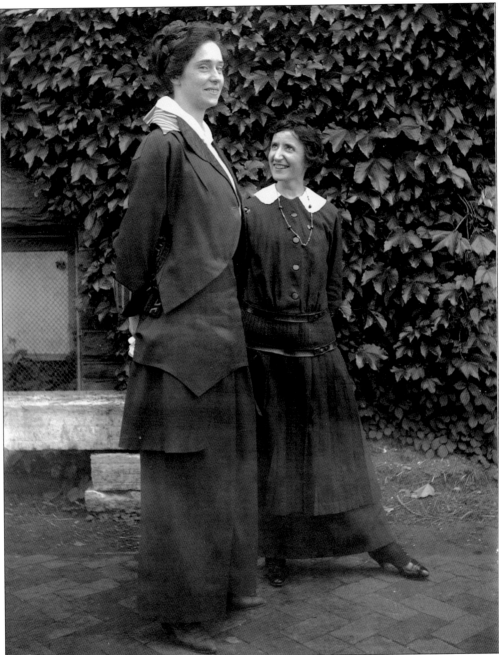

LUCY JESTON HAMPTON. Hampton (left) was a Professor of History at Central State from 1910 to 1958. In addition, she was the founder of the college's historical society and museum in 1915; she attended the League of Nations conference in Geneva in 1923; she was the Curator of the Laboratory of History from 1915 to 1958; she served as a director and organizer for the Oklahoma League of Nations Association; and she was the first Director of International Relations for the American Association of University Women in Oklahoma. Hampton was also a public lecturer from 1919 to 1965. She was posthumously named to the Edmond Historic Hall of Fame in 1982. (Special Collections/Archives, University of Central Oklahoma Library.)

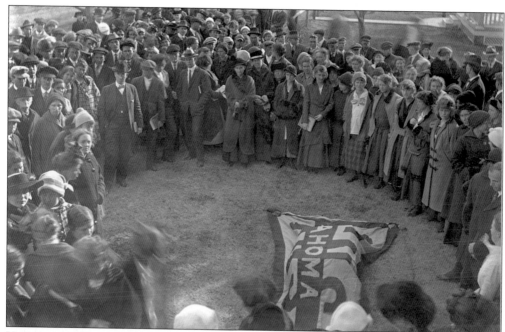

HISTORICAL MARKER. One of Hampton's first accomplishments as president of the historical society was to have a granite marker placed at 19 North Broadway. The marker read, "Central State Normal Began Nov. 9, 1891 With One Teacher and 23 Students, 1915 Annual Enrollment 2985, C.S.N. Historical Society 1915." With the marker, a time capsule was buried that unfortunately was destroyed when the Methodist Church burned in 1927. (Special Collections/Archives, University of Central Oklahoma Library.)

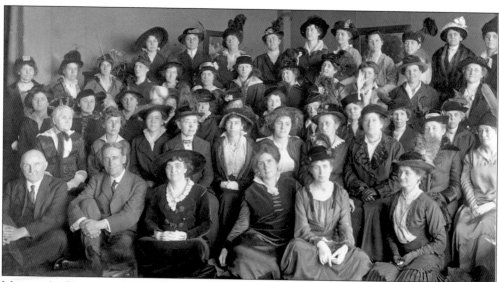

MOTHER'S CLUB. Mother's Club members pose with Principal B.F. Nihart (front row left), President Charles Evans, and Emma Estill Harbour. Ms. Harbour, later Dr. Harbour, would remain at Central for 40 years as a professor in the Social Sciences Department. Central State was the first state school in Oklahoma to institute a Mother's Club. (Special Collections/Archives, University of Central Oklahoma Library.)

THE WORLD'S GREATEST ATHLETE.
Jim Thorpe, a Native American from
the Sac and Fox tribe, visited CSN
in 1916. At the 1912 Olympics,
Thorpe became the first and only
person to win gold medals in both the
Pentathlon and the Decathlon. He was
also the first American to play both
professional baseball and professional
football. Thorpe is pictured with his
wife, Iva Miller Thorpe, and their
son James, Jr. (Special Collections/
Archives, University of Central
Oklahoma Library.)

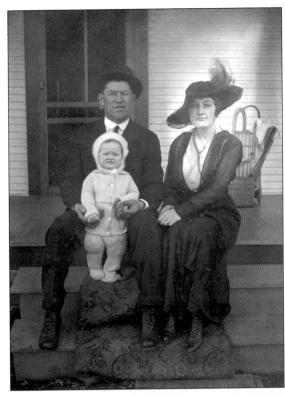

EDMOND CELEBRATES. The whole
town came out to honor Central's
victory in the triangular debates of
April 1916. Central State won the
decisions against both Durant and
Tahlequah. The celebratory crowds
gathered along Edmond Street.
Howard's Drug Store is visible in the
background. (Special Collections/
Archives, University of Central
Oklahoma Library.)

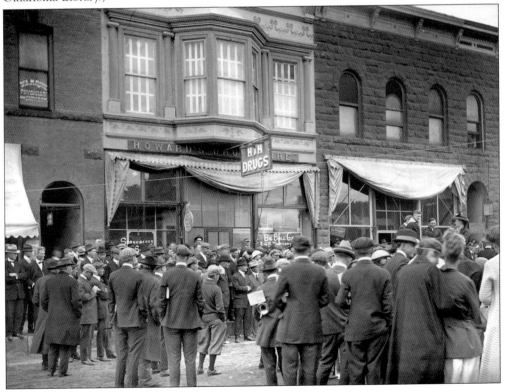

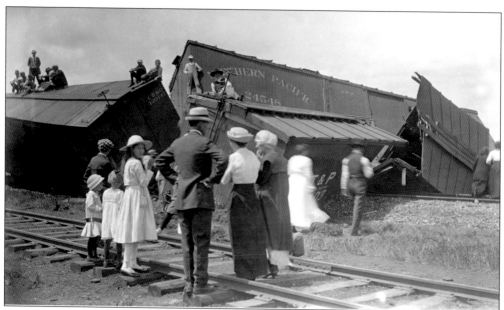

TRAIN WRECK. On Sunday May 20, 1917, a northbound freight train wrecked after 12 cars left the track at the south part of the Edmond Santa Fe yards. The train originally came from Arkansas City. The wreck seriously blocked traffic, but did not seem to hinder people who came out to watch the cars being cleared away. (Special Collections/Archives, University of Central Oklahoma Library.)

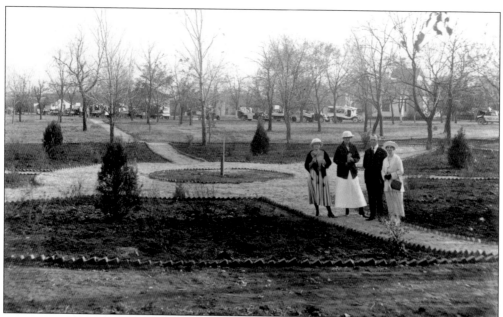

A DAY IN THE PARK. Every city needs a nice park and Edmond was no exception. Mitch Park was proudly landscaped by the Ladies Federated Clubs and boasted its own sunken garden. The park was located where Edmond's post office now stands on Broadway. Left to Right are Mrs. Arnett, Mrs. William Huffman, W.G. Hines, and Mrs. I.W. Rodkey. (Special Collections/Archives, University of Central Oklahoma Library.)

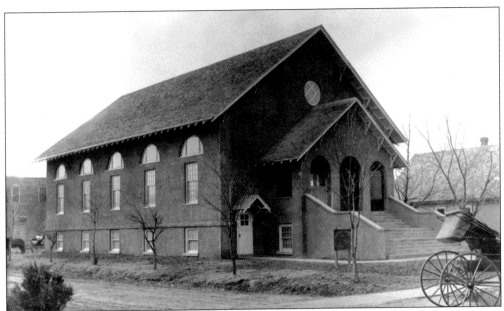

NEW CHURCH. The Baptists of Edmond were pleased with the finished construction of their new stucco church building. This picture, taken on January 1, 1917, shows the front side of the new church with a buggy at the front and another buggy nearly hidden in the back. The new Baptist Church was located at Main and Littler. (Special Collections/Archives, University of Central Oklahoma Library.)

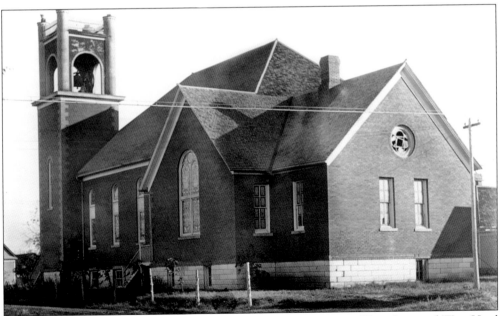

METHODIST CHURCH. In 1890, lots were purchased at the corner of Broadway and West Hurd for the purpose of building a little frame church for the Methodists. The church building was loaned out and used by the Normal School from 1891 to 1892. The church, also called the Sarah Riley Memorial, was located at 19 North Broadway. This is a back view of the church. (Special Collections/Archives, University of Central Oklahoma Library.)

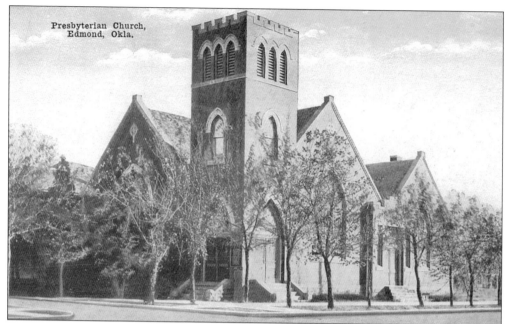

PRESBYTERIAN CHURCH. On March 21, 1890, John H. Aughey preached the first sermon for the Presbyterians. A church was built and dedicated in the summer of 1891. The location, however, seemed too far from town, so the church moved just east of Broadway and Main Street. By 1906, a larger building was required. This is the end result of the church that was dedicated in 1908. (Purchased from Country Collectibles Antique Shop.)

FIRST CHRISTIAN CHURCH. The congregation of the First Christian Church of Edmond came together in 1899. A church was built and dedicated in 1902. The red brick building, pictured here, was located at North Broadway and East Campbell. (Special Collections/Archives, University of Central Oklahoma Library.)

PHOTOGRAPHY INSTRUCTOR. John Davis' customary position would have been on the opposite side of the camera, but luckily he took the time to pose for this picture on his porch in 1917. Davis was the founder of Central State Normal's photography classes. He was also a professor of physics and chemistry from 1908 to 1919. Davis and his class are almost entirely responsible for the University of Central Oklahoma's current Glass Plate Negative Series of over 2,000 images taken from 1911 to 1920. Davis' unconventional artistic style gives us an informal glance into everyday, early-20th century life in Edmond. (Bill Williams Collection, Special Collections/ Archives, University of Central Oklahoma Library.)

WORLD WAR I. The assassination of Archduke Franz Ferdinand, heir to the Austro-Hungarian Empire, on June 28, 1914, seemed like a distant event to America. However, the entangling alliances of Europe made the incident something that plunged most of the continent into war. The U.S. policy of strict neutrality dissolved with Germany's use of submarine warfare and the discovery of the Zimmerman Telegram. Congress declared war on Germany on April 6, 1917. The entire nation prepared for the Great War. The Student Army Training Corps barracks was housed on the top floor of the Old North Tower. About 150 men trained on campus. (Special Collections/Archives, University of Central Oklahoma Library.)

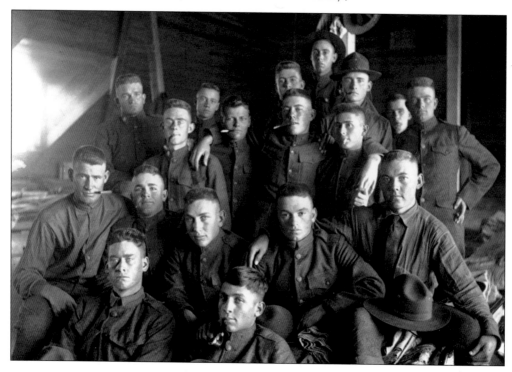

DR. EMMA ESTILL-HARBOUR. Harbour (third from left) joined the Social Sciences staff at Central in 1912. She went on to earn a Masters and Ph.D from Oklahoma University. During the Great War, later called World War I, she served at Neuf Chateau in France as a member of the American Legion and Women's Overseas League. Her many accomplishments placed her in the Oklahoma Hall of Fame in 1935. (Kathryn Kunc Collection, Special Collections/Archives, University of Central Oklahoma Library.)

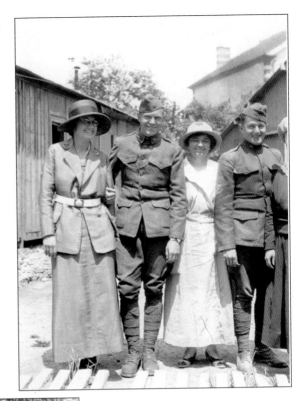

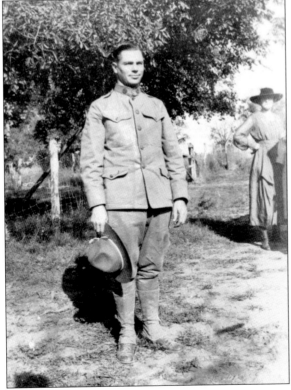

SOLDIER. In this picture, taken in the fall of 1918, Elmer Petree posed in his uniform. Petree had the distinction of starting and operating the first printing office at Central in 1915. He later helped establish the state teacher's retirement system, and in 1965 a group attempted to get East Hall at Central State renamed Petree Hall. (Special Collections/ Archives, University of Central Oklahoma Library.)

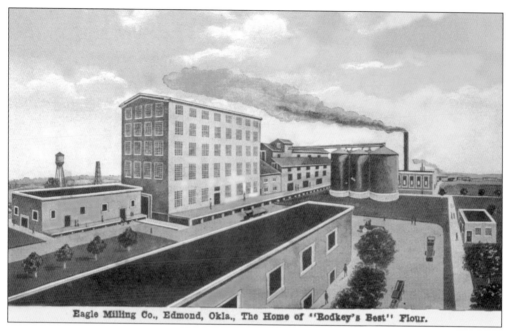

Eagle Milling Co., Edmond, Okla., The Home of "Rodkey's Best" Flour.

MAJOR INDUSTRY. In 1897, Isaac W. Rodkey and George Farrar bought the Gallihugh-Martin Flour Mill (*above*). They renamed it the Eagle Milling Co. By 1914, the business was going strong and Rodkey bought out Farrar and hired his son Earl to help out. The family business was now called Rodkey Flour Mill. For many years, the mill was Edmond's largest employer. Isaac's other son Don Rodkey (*below*) is pictured in his World War I naval uniform. (Special Collections/Archives, University of Central Oklahoma Library.)

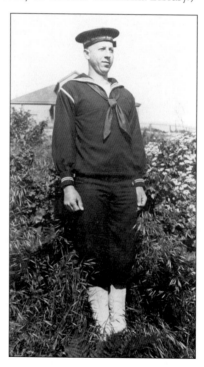

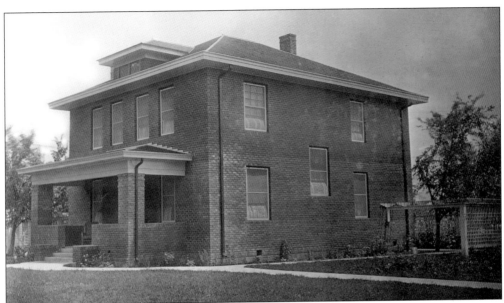

PRESIDENT'S HOUSE. The president's home was completed and occupied on the campus of Central State Normal School in 1918. The president at the time of the completion of the house was J.W. Graves. To aid in the war effort, Graves headed up a commission of college officials that went to Fort Sheridan, Illinois, to learn how to get people physically fit for war. (Special Collections/Archives, University of Central Oklahoma Library.)

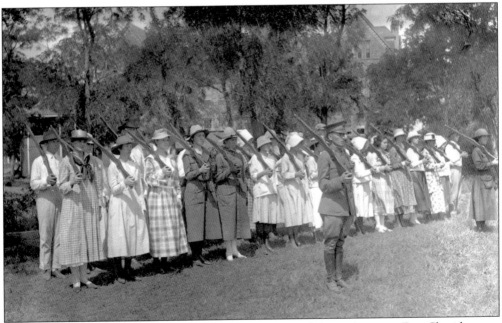

COMPANY "B" GIRL'S MILITARY. One of the results of Graves' trip to Fort Sheridan was the initiation of a military training program for women. Carrie Belle Wantland directed this program. The women of "Company B" are pictured here practicing with their wooden rifles. The training was intended to prepare women to teach military fundamentals in school. (Special Collections/Archives, University of Central Oklahoma Library.)

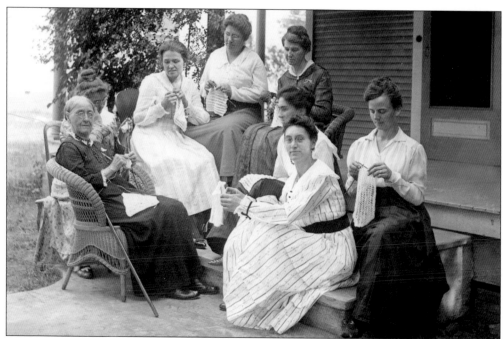

LENDING A HAND. This is a July 1917 image of a Red Cross knitting session. The eight unidentified women must have spent the afternoon knitting socks and scarfs on one of their porches. All of Edmond helped in the war effort in one way or another. (Special Collections/Archives, University of Central Oklahoma Library.)

AMERICAN LEGION DRIVE. W.Z. Spearman, E. Hunley, and G. Bigham help out with the drive. The war officially ended with the signing of an armistice on November 11, 1919. On June 28, the fate of Germany and the rest of the world was sealed with the signing of the Treaty of Versailles. The harsh reparations—as President Wilson had warned against—would later prove to be the breeding ground for the emergence of Adolf Hitler. (Linda Jones Collection, Special Collections/Archives, University of Central Oklahoma Library.)

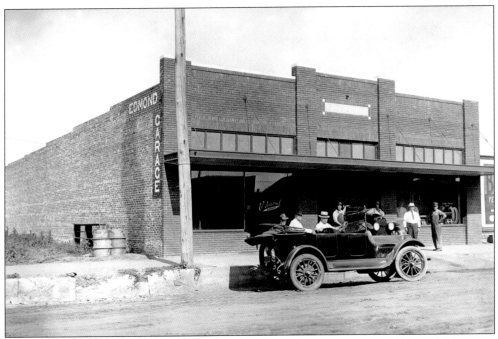

BENDER BUSINESS. Edwin Augustus Bender lived on a farm northwest of Edmond. He was a large stockholder in Citizens National Bank and even served as president of the bank for a number of years. He also owned the building pictured above. Bender's son, Raymond A. Bender, used the building for his business, the Edmond Garage. The car is a convertible Ford Model-A. (Special Collections/Archives, University of Central Oklahoma Library.)

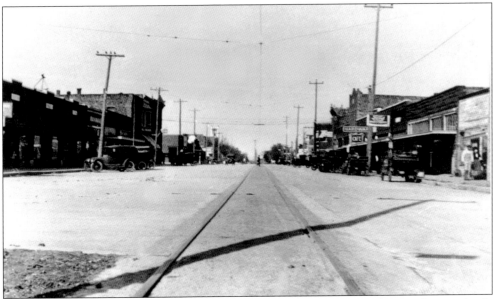

DOWNTOWN. This is a 1920s view of downtown Edmond. The Interurban tracks are clearly visible running through the center of the street. Automobiles were now becoming more and more common around town. (Special Collections/Archives, University of Central Oklahoma Library.)

ROAD TRIP. If you preferred to take a trip away from Edmond and travel to Oklahoma City by car in the 1920s, this was the bumpy dirt road that greeted you. The best stop for gas on your way out of town was the Bradbury Station at the intersection of US 66 and US 77. (Linda Jones Collection, Special Collections/Archives, University of Central Oklahoma Library.)

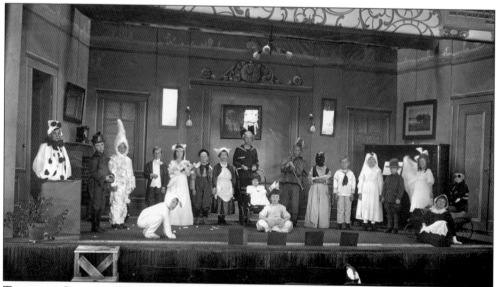

TRAINING SCHOOL. Central State Teacher's College included a training, or demonstration, school for graduate students. This gave the teacher's-in-training first hand experience with students. This photograph shows a Christmas exercise with costumed children on the Administration building stage. There appear to be a jack-in-the-box, a rabbit, military men, and a muse, among others. (Special Collections/Archives, University of Central Oklahoma Library.)

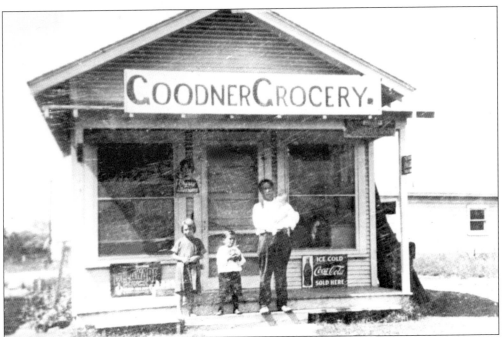

GROCERY STORE. Goodner's Grocery was located on Normal Circle, facing east from the block where the Max Chamber's library was eventually built at the corner of Ayers and University. The store was known as "The Student's Friend." Ruth Goodner is pictured to the left at eight years of age in 1923. She went on to graduate from Central in the 1930s. (Ruth King Goodner Collection, Special Collections/Archives, University of Central Oklahoma Library.)

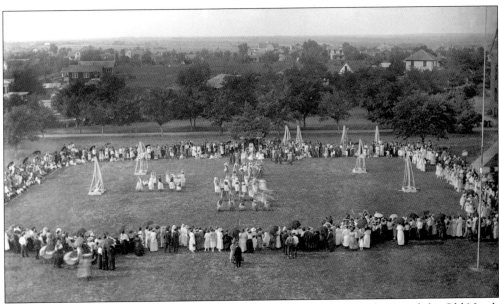

MAY DAY. Students and Edmondites celebrate May Day on the grounds around the Old North Tower in 1920. Edmond Street and houses are clearly visible in the background. That same year, Central State was honored to have former United States president, William H. Taft, visit the campus. (Special Collections/Archives, University of Central Oklahoma Library.)

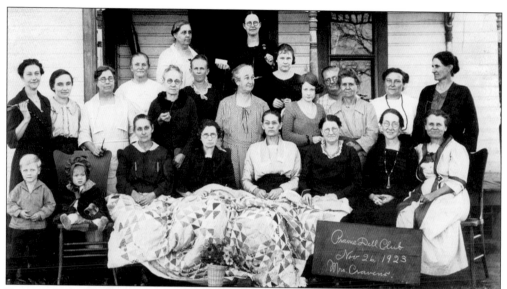

PRAIRIE DELL CLUB. The women of the Prairie Dell Quilter's Club pose on Mrs. Craven's porch with their quilt on November 26, 1923. Gertrude Scott, who graduated from Central in the early 1920s, donated the picture. She could only identify the two women dressed in dark dresses on the right side of the front row. The first woman on the left was Rosa M. Scott, and to her right is Laura Gilmore. (Linda Jones Collection, Special Collections/Archives, University of Central Oklahoma Library.)

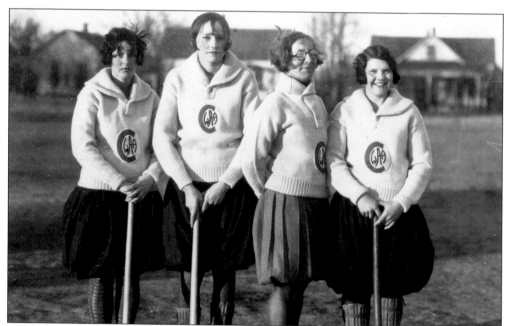

WAA. In 1922, Miss Zona Smith formally organized athletic training for women at CSTC and gave females a chance to earn a letter. By 1925, the popularity of the Women's Athletic Association (WAA) had grown to include 250 women. Pictured above, from left to right, are Irlene Murphy, Margaret Albers, Zona Smith, and Celia Coil. (Gary and Martha Hall Collection at the Arcadian Inn Bed & Breakfast.)

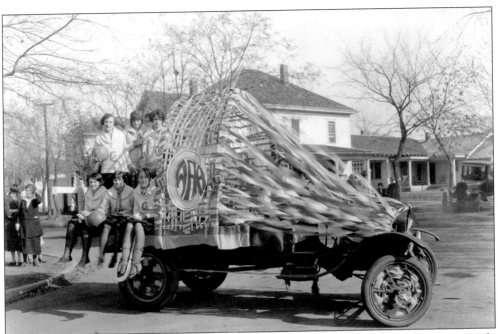

WOMEN ON CAMPUS. No celebration of a homecoming would be complete without a properly decorated automobile or two. The women of CSTC's Women's Athletic Association proudly display their handy work in this 1925 photograph. (Gary and Martha Hall Collection at the Arcadian Inn Bed & Breakfast.)

WEEKEND HIKING. The requirements to receive an athletic sweater for the WAA were that each girl hike a distance of 350 miles during the school year and win in team sports. This is a photograph of the 1925 WAA arriving in Oklahoma City after their first hike. Floranna Ruhl participated in the hikes and proudly recorded each location and miles earned. (Gary and Martha Hall Collection at the Arcadian Inn Bed & Breakfast.)

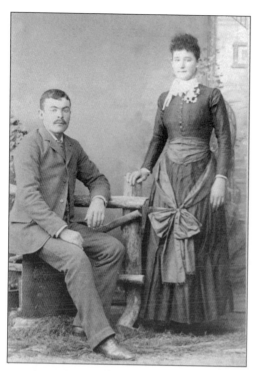

MAYOR. G.H. Fink married Bennettie Nave in 1891. They posed for this picture just before their nuptials. Fink was born in Germany and came to Edmond in 1890. He dabbled in real estate, banking, and community leadership. At the time of his death in 1930, he was the President of Citizens Bank and Mayor of Edmond. (Courtesy of Lucille Warrick and Genevieve W. Slade, Special Collections/Archives, University of Central Oklahoma Library.)

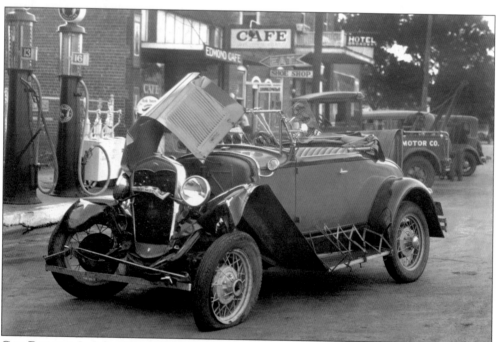

CAR REPAIRS. In July 1905 the first automobile came to Edmond. As a safety measure the speed limit in town was set at five miles per hour. By 1931, many of Edmond's residents owned a car, and gasoline pumps and garages became a common sight. This automobile, with a Missouri license tag, apparently made a stop in Edmond for a few repairs. (Special Collections/Archives, University of Central Oklahoma Library.)

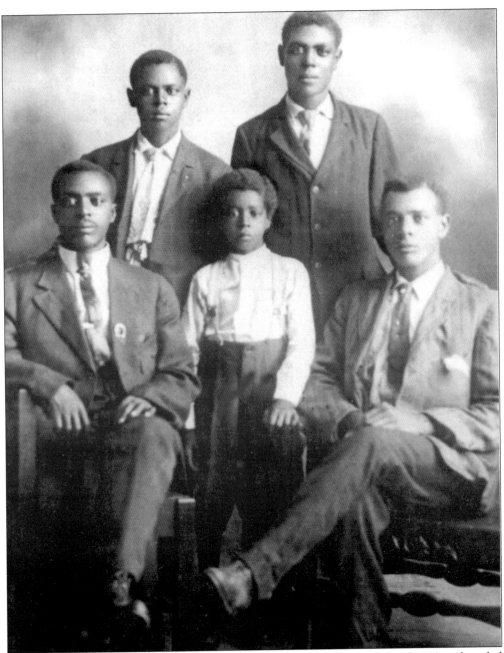

LITTLE KNOWN CEMETERY. John A. and Ophelia Gower made the Run of 1889 and settled in an African-American settlement known as "Nonsey." They went on to open the Gower Cemetery in the 1920s. By 1930, Gower saw a need and developed a plan to include an indigent section for the less fortunate of society. In 1986, Gower's daughter Myrtle and her husband David set about restoring the cemetery located at Covell Road between Douglas Boulevard and Post Road. They renamed it Gower Memorial Cemetery in honor of those early settlers and veterans laid to rest in the cemetery over the years. The Gower's sons Willie T. Sr., Henry B., Roosevelt, Daniel, and Garfield are pictured above. (Myrtle Gower-Thomas Collection, Special Collections/Archives, University of Central Oklahoma Library.)

EDMOND HIGH SCHOOL. As the population rose, Edmond residents saw a need for a major addition to the community. In February of 1924, voters approved a bond of $83,000 for a new high school building. Construction moved quickly and the new Edmond High School was opened in November of that same year. This is a view of the exterior south entrance. (Special Collections/Archives, University of Central Oklahoma Library.)

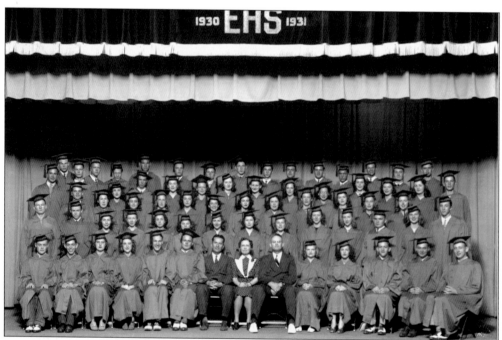

CLASS PICTURE. This is a picture of Edmond High's class of 1930-31. Edmond High won the North Central Conference meet in 1930, by exhibiting excellence in the areas of track, music, and literature. One student, Marion Marks, went on to win a hurdles competition in Kansas that allowed him to move forward to another competition in Chicago. (Special Collections/ Archives, University of Central Oklahoma Library.)

Four-Legged Resident. Students of Edmond High School were to become known as the Bulldogs. But in the 1920s and 1930s, the "lord and master" of Central State's campus was Emma Estill Harbour's bulldog, Billy. Billy was a regular on campus and spent most of his days napping in Dr. Harbour's classroom. His image appears repeatedly in campus photos from this era. (Special Collections/ Archives, University of Central Oklahoma Library.)

Thompson's Book & Supply Company. Thompson's ad in the 1931 Bronze Book (CSTC's yearbook) claimed, "We Make the Prices for Others to Follow." At that time, Thompson's was located at 117 North College. They can now be found at 101 North University. Thompson's has been serving the school supply needs of Central students and Edmond residents for over seventy years. (Special Collections/Archives, University of Central Oklahoma Library.)

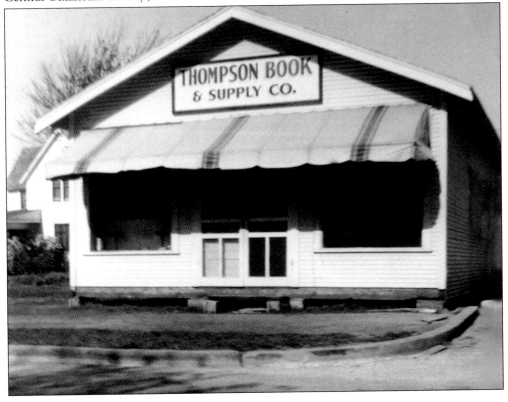

PAAS FUNERAL HOME. Geo E. Paas came to Edmond in 1911. He purchased the Waldorf Hardware Store and renamed it Paas Hardware. Ever the entrepreneur, Paas also worked as an undertaker and embalmer. This 1930s photograph shows the Paas Funeral Home at 201 E. Campbell. Unfortunately, Paas never did get to use the building—he died in 1927. (Special Collections/Archives, University of Central Oklahoma Library.)

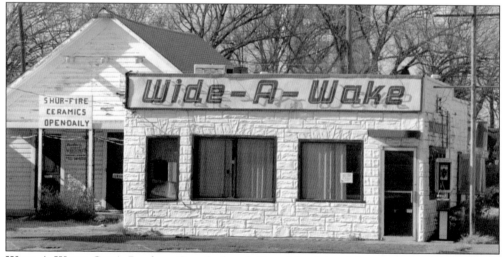

WIDE-A-WAKE CAFÉ. Brothers Crawford and Gene Noe joined their wives, Cleo and Essie Mae, in a business adventure that would become an Edmond staple for 48 years. The Wide-A-Wake Café opened in October of 1931 in a rented building with a short counter and two tables. The Wide-A-Wake promised and delivered "Good Food, Well Served." The café never closed and became a necessary stop for travelers on highways 66 and 77. (Betty Noe Lamson Collection, Special Collections/Archives, University of Central Oklahoma Library.)

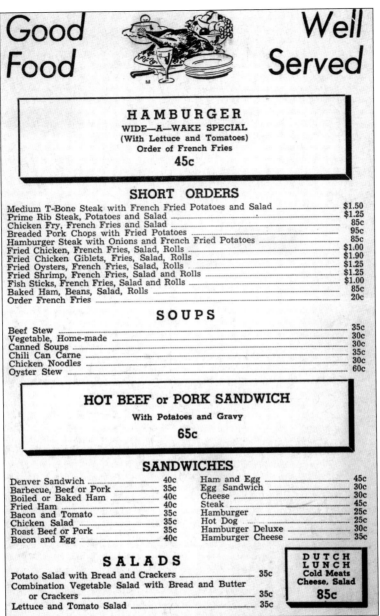

Good Food

Well Served

HAMBURGER
WIDE—A—WAKE SPECIAL
(With Lettuce and Tomatoes)
Order of French Fries
45c

SHORT ORDERS

Medium T-Bone Steak with French Fried Potatoes and Salad	$1.50
Prime Rib Steak, Potatoes and Salad	$1.25
Chicken Fry, French Fries and Salad	85c
Breaded Pork Chops with Fried Potatoes	95c
Hamburger Steak with Onions and French Fried Potatoes	85c
Fried Chicken, French Fries, Salad, Rolls	$1.00
Fried Chicken Giblets, Fries, Salad, Rolls	$1.90
Fried Oysters, French Fries, Salad, Rolls	$1.25
Fried Shrimp, French Fries, Salad and Rolls	$1.25
Fish Sticks, French Fries, Salad and Rolls	$1.00
Baked Ham, Beans, Salad, Rolls	85c
Order French Fries	20c

SOUPS

Beef Stew	35c
Vegetable, Home-made	30c
Canned Soups	30c
Chili Can Carne	35c
Chicken Noodles	30c
Oyster Stew	60c

HOT BEEF or PORK SANDWICH

With Potatoes and Gravy
65c

SANDWICHES

Denver Sandwich	40c	Ham and Egg	45c
Barbecue, Beef or Pork	35c	Egg Sandwich	30c
Boiled or Baked Ham	40c	Cheese	30c
Fried Ham	40c	Steak	45c
Bacon and Tomato	35c	Hamburger	25c
Chicken Salad	35c	Hot Dog	25c
Roast Beef or Pork	35c	Hamburger Deluxe	30c
Bacon and Egg	40c	Hamburger Cheese	35c

SALADS

Potato Salad with Bread and Crackers	35c
Combination Vegetable Salad with Bread and Butter or Crackers	35c
Lettuce and Tomato Salad	35c

DUTCH LUNCH
Cold Meats
Cheese, Salad
85c

MY OIL FIELD DAYS. I'd wake up in the morning, just somewheres around six. It seemed like an early morning, for I was usually in an awful fix / I'd jump out of bed and pull on my duds, to the bathroom looking for a towel, water and suds / I'd hurry around the room for I was nearly always late, run out and crawl in that old Ford V-Eight / Push down on the throttle and give her all she would take, for I knew that I was headed for the dear old Wide-A-Wake / I'd walk in and say 'Good Morning Pals,' order a Number Seven and look at the pretty gals / I'd eat that Number Seven and hurry on away, for I had to get to work, or the Ohio would stop my pay / I'd go out to work or at least put in my time, I always worked for my money, but never saved a dime / Now as I sit here writing, there's no use to fret, for why should I ever have anything to regret?—Jimmie George Jr. (Betty Noe Lamson Collection, Special Collections/Archives, University of Central Oklahoma Library.)

CAMPUS EVENT. The Women's Recreation Association put on a circus program in 1933. This photograph shows the participants of the circus showing off their costumes. That same year, several members of the 1904 football squad were the honored guests at the homecoming celebration. Ed Klein scored the school's first touchdown. Klein donated the football he carried that day to the Central trophy case. (Special Collections/Archives, University of Central Oklahoma Library.)

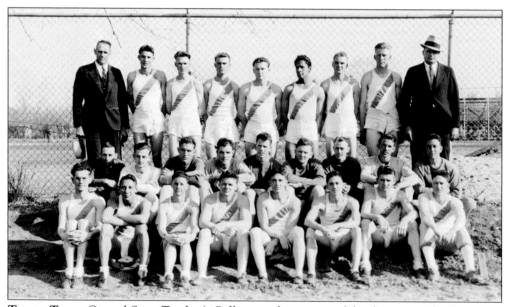

TRACK TEAM. Central State Teacher's College track team posed for this picture by the tennis courts in 1934. Central's athletic department had become a force to be reckoned with and the track team was no exception. They won the state championship every year from 1930 to 1938. (Special Collections/Archives, University of Central Oklahoma Library.)

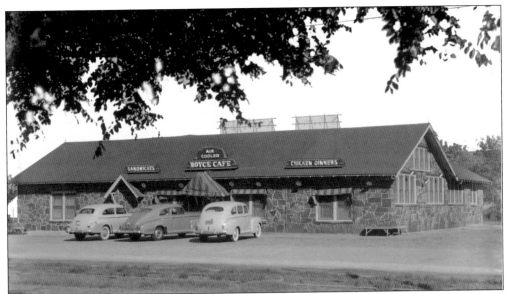

ROYCE CAFÉ. Royce Adamson opened the Royce Café in 1933. The building, made from native red-rock, was located at Fourth and South Broadway. This is an exterior view of the café on July 3, 1934. (Special Collections/Archives, University of Central Oklahoma Library.)

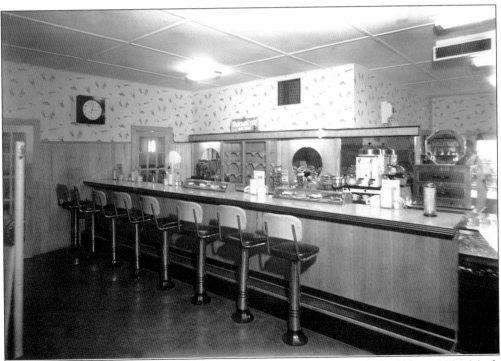

INSIDE THE ROYCE CAFÉ. This is what the counter of the Royce Café looked like in 1934. Much like the Wide-A-Wake, the Royce Café never closed. A customer could enjoy an assortment of appetizers, soups, meats, and vegetables. The café also promised that if your check exceeded 25¢ then the second cup of coffee was on them. (Special Collections/Archives, University of Central Oklahoma Library.)

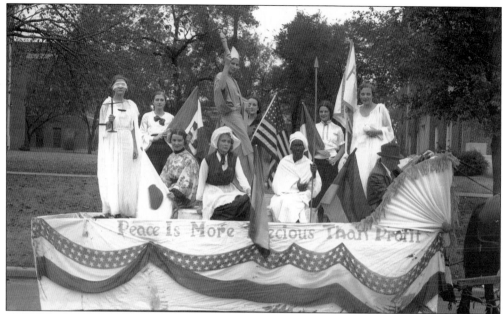

1936 HOMECOMING FLOAT. This is a photograph of the Shakespeare Club's float traveling slowly down Main Street. The Shakespeare Club, organized in 1908, was the first girls club at Central. The club's function was "to promote a better understanding of the works of Shakespeare and also to carry out numerous social activities." (Special Collections/Archives, University of Central Oklahoma Library.)

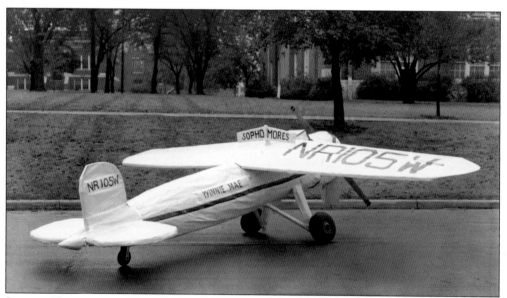

SPECIAL HOMECOMING FLOAT. The sophomore class chose to pay tribute to Oklahoman Wiley Post with their homecoming float. In the 1930s, Post and the Winnie Mae plane completed two around-the-world record flights and a series of special high-altitude sub stratospheric research flights. Post died along with another Oklahoma native, Will Rogers, in a plane crash at Point Barrow, Alaska, in 1935. (Special Collections/Archives, University of Central Oklahoma Library.)

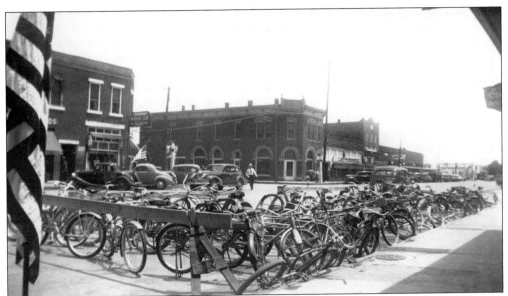

LOCAL ENTERTAINMENT. Around 1917, William Zebadi Spearman opened the Gem Theatre. The theatre was located on the west side of Broadway between First and Second streets. The popularity of movie escapism eventually led Spearman to set up an outdoor screen, or what is now called a "drive-in" theater. This 1934 image shows bikes lined up in front of the Gem Theatre. (Linda Jones Collection, Special Collections/Archives, University of Central Oklahoma Library.)

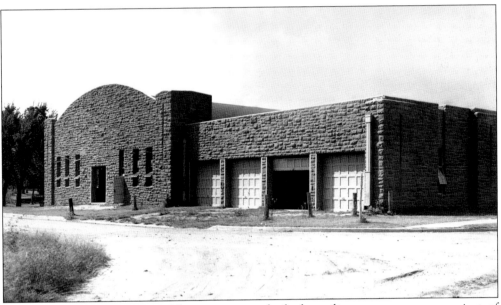

NATIONAL GUARD ARMORY. The armory was built for military purposes as a project of the Works Progress Administration (WPA) in 1936. The building served as the regimental headquarters for the 179th Infantry, 45th Division during World War II and the Korean War. The building now serves as the "headquarters" of the Edmond Historical Society Museum. This is a view of the exterior south entrance. (Special Collections/Archives, University of Central Oklahoma Library.)

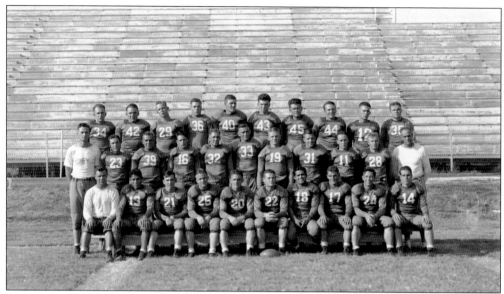

WINNING FOOTBALL TEAM. Central's football team was named Collegiate Conference Champions in 1937. They were not alone in receiving accolades; the track, baseball, and basketball teams were also recognized champions. Charles Wantland had passed the coaching torch on to fellow University of Oklahoma athlete Claude Reed (second row, far right) in 1930 to pursue a career in the insurance business. (Special Collections/Archives, University of Central Oklahoma Library.)

GROWING CAMPUS. This is a 1930s back view of the Central State's campus from the tennis courts. In 1939, the state legislature passed a law that made the school into a four-year Liberal Arts college. With the new status came a new name, Central State College. (Special Collections/Archives, University of Central Oklahoma Library.)

Three

1938–1963

Locally, the theme of 1938–1963 was growth. In fact, this era was to become an indicator of the enormous growth rate that was just over the horizon. A population breakdown by decade puts Edmond's populace at 4,002 in 1940, 6,086 in 1950, and 8,577 by 1960. Obviously this growth brought with it a few additions. By 1963, Edmond was a city of eight grade schools, a hospital, two banks, six parks, two newspapers, twelve churches, one theater, and a public swimming pool. This influx of new business put Edmond at well over one hundred stores and shops.

Naturally, country and global events had an effect on Edmond, as well. War, in the form of World War II, Korea, and Vietnam was at the forefront. A different kind of war, the Cold War would also take hold during this time. The two major players in this war were also the major competitors in the Space Race. Television captured the country's attention, and Americans were stunned by the assassination of President John F. Kennedy.

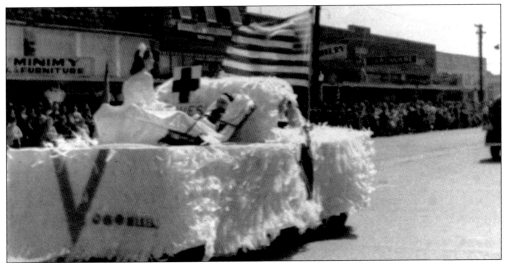

VICTORY DAY. Americans came together and abandoned their isolationist tendencies the day after the attack on Pearl Harbor on December 7, 1941. Edmondites again did what they could to help. Central State College's Homecoming Day Parade Float signified the joy that Edmond and the world felt with the end of World War II. The victory float is pictured here parading down Broadway in 1945. (Bettye Jane Johnston Collection, Special Collections/Archives, University of Central Oklahoma Library.)

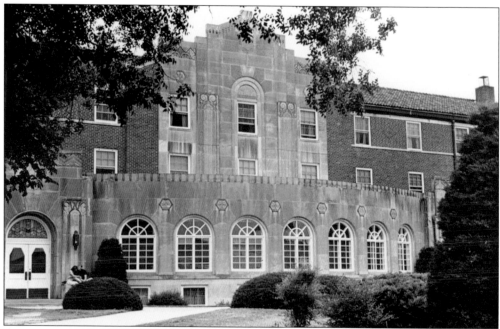

MURDAUGH HALL. By 1938, Central State had seven major buildings: the Old North Tower, the Administration Building, Mitchell Hall, Evans Hall, Wantland Hall, Thatcher Hall, and Murdaugh Hall—pictured above. That same year the college graduated a record 415 students. (Special Collections/Archives, University of Central Oklahoma Library.)

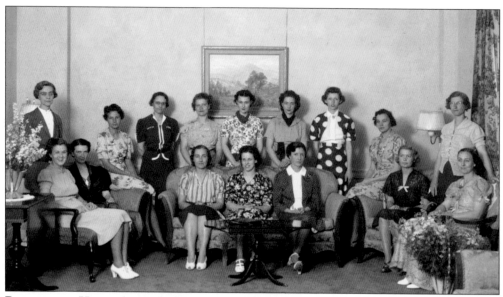

RESIDENTIAL HALLS. In 1935, the government gave CSTC a loan through the Public Works Administration for the construction of two residential halls on campus. The two buildings, completed in 1937, were named for past presidents Richard Thatcher and Edmund Murdaugh. Thatcher Hall accommodated 150 boys, while Murdaugh Hall housed 300 girls. The lounge area of Murdaugh Hall with residents is pictured above. (Special Collections/Archives, University of Central Oklahoma Library.)

BRONCHO STADIUM. In 1922, Charles Wantland's wife suggested the name "Bronchos" for the school's football team. It stuck and became the team name. Through a WPA project, Broncho Stadium was constructed in 1937-38. The WPA also laid steam tunnels from all the major buildings to the campus heating plant and re-landscaped the campus grounds. (Special Collections/ Archives, University of Central Oklahoma Library.)

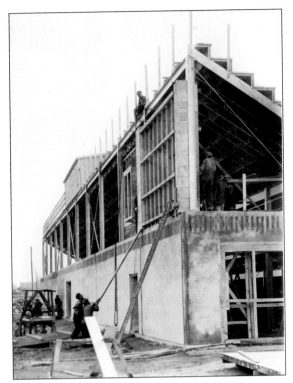

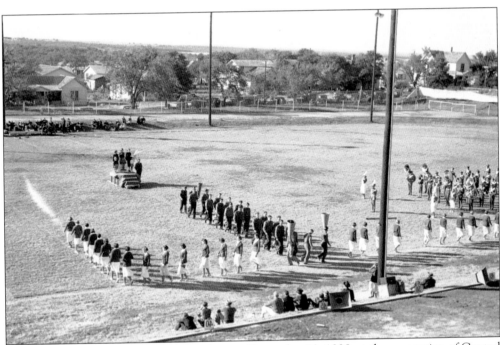

HOMECOMING. This photograph was taken on November 19, 1938, at the coronation of Central State's new homecoming queen. On that same day during the football game the halftime ceremonies including a mile exhibition run by world record long distance runner Glenn Cunningham. (Special Collections/Archives, University of Central Oklahoma Library.)

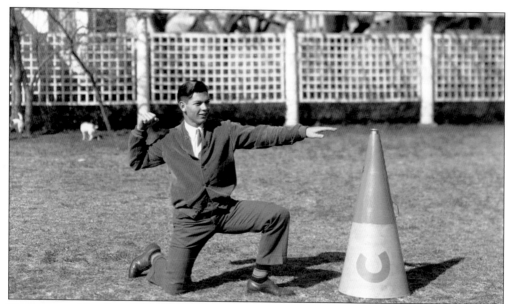

SPUR CLUB. The Spur Club was founded in 1924 as a pep club for boys. Their motto: "Spur the Bronchos on to victory." The Spur Club "yell" leader, Gene Morris, is pictured above in 1937. Morris had a lot to yell about during the 1937-38 season—Central won state championships in football, tennis, and track. (Special Collections/Archives, University of Central Oklahoma Library.)

DAD'S DAY. In 1938, Central began celebrating holidays for parents. April 30 was deemed Mother's Day and November 11 was slotted for Father's Day. On the first Father's Day, residents of Murdaugh Hall posed with their respective dads in front of their dorm. Central's president, John D. Mosely, is pictured in the center of the group. (Special Collections/Archives, University of Central Oklahoma Library.)

BONFIRE TOWER. By 1939, school spirit was at an all time high. Central State College was on a winning streak. Students pose on the bonfire tower they helped build to insure a victory over OU. The tower was built out of scrap lumber and reached a height of 30 feet. CSC went on to win the state championships in football, basketball, baseball, and tennis. (Special Collections/Archives, University of Central Oklahoma Library.)

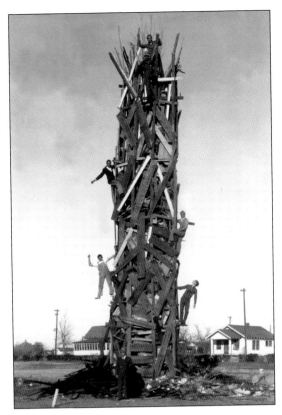

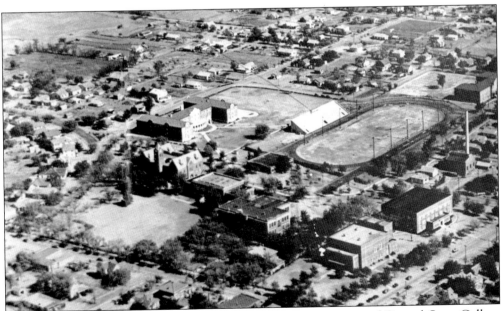

CAMPUS VIEW. This 1940s aerial view shows the growing campus of Central State College and parts of Edmond. By 1940, Central was graduating close to one hundred students yearly, Edmond's population was over 6,000, and streets were being improved and widened. (Special Collections/Archives, University of Central Oklahoma Library.)

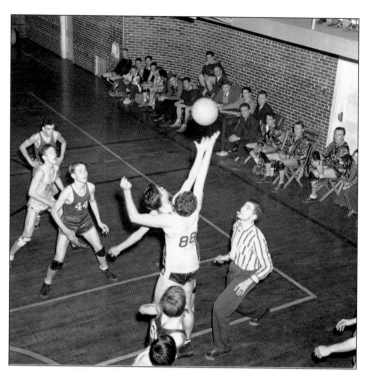

BASKETBALL GAME. High school students from the Training School play a basketball game on January 20, 1941 in the Wantland Field house. Physical education activities included indoor, outdoor, and intramural sports. The upper-level grades of the training school would eventually be dropped in the late 1940s. (Special Collections/Archives, University of Central Oklahoma Library.)

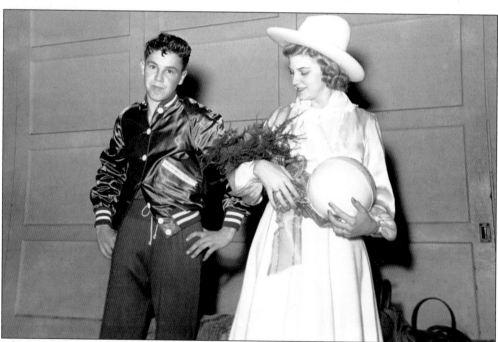

BASKETBALL QUEEN. Viola Raines, pictured with her escort, was named the High School Queen in January of 1941. Life would soon change for Americans with our entry into World War II. On December 7, 1941, the Japanese attacked Pearl Harbor, and on December 8th the United States declared war on Japan. Germany, in turn, declared war on the U.S. on December 11th. (Special Collections/Archives, University of Central Oklahoma Library.)

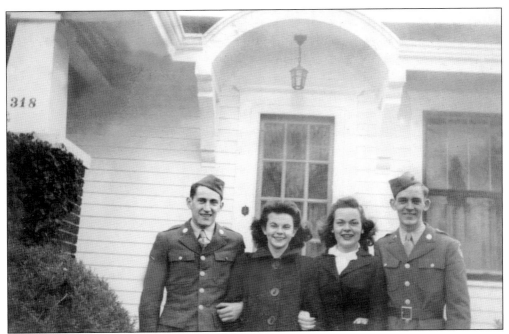

SOLDIERS. America was now mobilized for war, rationings were in effect, the draft age was lowered to eighteen, and women took over jobs that were traditionally reserved for men. Bertha Fordice (third from left), daughter of Edmond historian Stella Fordice, is pictured posing on her porch with a few friends. Men and women in uniform became a common sight in towns throughout the country. (Bertha Fordice Scoggins Collection, Special Collections/Archives, University of Central Oklahoma Library.)

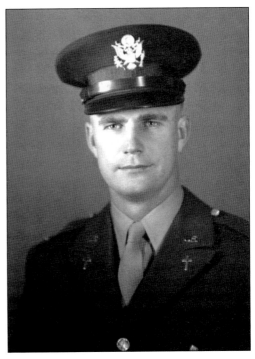

CHAPLAIN CHARLES RICHMOND. Richmond came to Edmond in 1939 to attend Central State. He went on to work as a principal with Deer Creek Schools. By the age of 24, duty called and he served in both World War II and the Korean War as an Army Chaplain. In the 1960s, he became Central's Dean of Student Affairs. (L.J. Hampton's Students at War Collection, Special Collections/Archives, University of Central Oklahoma Library.)

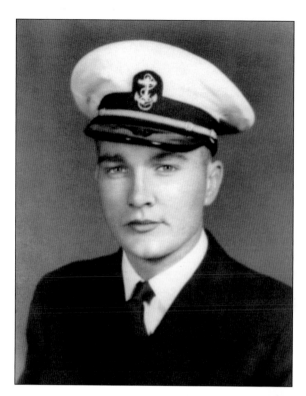

LT. SYLVESTER J. LINN JR. Linn was a Central State student who bravely served and survived during World War II as a naval aviator. In 1947, he was a member of the Admiral Byrd expedition to the South Pole. Sadly, he was killed in the crash of a navy patrol bomber just after take off at Kaena Point, Oahu, Hawaii, on November 27, 1950. (Special Collections/Archives, University of Central Oklahoma Library.)

TED ANDERSON. Anderson, a notable athlete, started his college career in 1935 at Central State and graduated in the summer of 1939. Like most Central graduates he pursued at career in education. Anderson was the junior high principal for a number of years and also served on the City Council. During World War II, he served as a Lieutenant. (L.J. Hampton's Students at War Collection, Special Collections/ Archives, University of Central Oklahoma Library.)

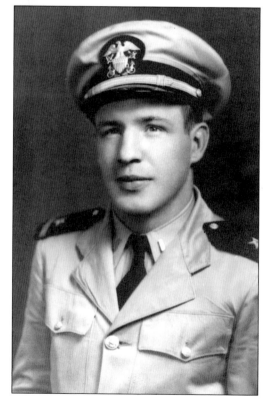

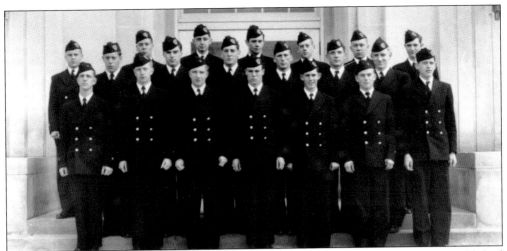

WAR TRAINING SERVICE SCHOOL. In 1939, the Civilian Aeronautics Authority established a training school for pilot cadets on CSC's campus. By 1942, an Army Air Force Training Detachment had also opened on campus. The six hundred cadets resided in Murdaugh and Thatcher Halls for their eight weeks of study. By 1944, over 500 cadets from 36 states had trained at CSC. Cadets are pictured on the steps of Thatcher Hall. (Robert John Pielemeier Jr. Collection, Special Collections/Archives, University of Central Oklahoma Library.)

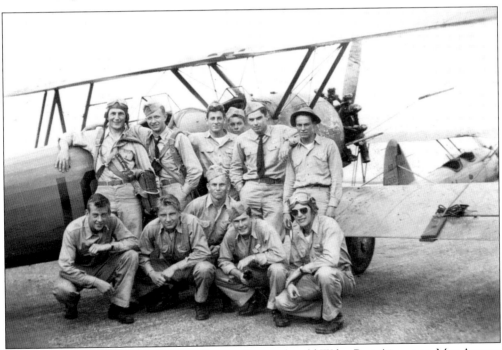

CADETS IN TRAINING. This photograph was taken at the old Wiley Post Airport on May Avenue and shows a group of cadets beside a bi-plane called "Yellow Peril." From left to right the cadets are pictured as follows: (front row) W. Refuss, W. Ranney, L. Sides, and P. Quimby; (middle row, kneeling) I. Shimon; (back row) D. Schnieder, R. Rovelstad, J. Peterson, J. Smith, J. Rhine, and R. Pielemeier. (Robert John Pielemeier Jr. Collection, Special Collections/Archives, University of Central Oklahoma Library.)

JOHN KESSLER. Kessler was a 1929 graduate of Central. He was EHS's football coach for eight years before serving his country during World War II. After the war, he returned home and was elected Mayor in 1950. For a short time, he owned the Paas Funeral Home with J.B. Shadle. He later served on the Edmond City Council. (L.J. Hampton's Students at War Collection, Special Collections/ Archives, University of Central Oklahoma Library.)

SIDNEY C. BRAY. Bray served as the Oklahoma and Regional Director of U.S. War/Savings Bond Sales Program for the turbulent years of 1942–1965. He was a veteran of World War I, and Sales Manager for General Motors prior to 1942. Bray was inducted into the Edmond Hall of Fame in 1983. From left to right are J. Wisdona, A. Hornbeck, S.C. Bray, Lt. Day, and M. Blackridge. (Sidney C. Bray Collection, Special Collections/Archives, University of Central Oklahoma Library.)

LIFE AFTER WORLD WAR II. World War II officially ended in 1945 with the surrender of Germany on May 7 and Japan's surrender on August 15. The world was forever changed by the war, but everywhere people tried to get back to "normal." The Central State homecoming football queen candidates gathered for this picture in the fall of 1947. (Special Collections/ Archives, University of Central Oklahoma Library.)

Y-CHAPEL OF SONG. Students, faculty and friends of Central State helped accumulate the funds necessary for construction of the chapel on the campus grounds. The purpose of the chapel was not public assembly, but rather for meditation and prayer. Ground was broken for the Y-Chapel on November 1, 1948. (Special Collections/Archives, University of Central Oklahoma Library.)

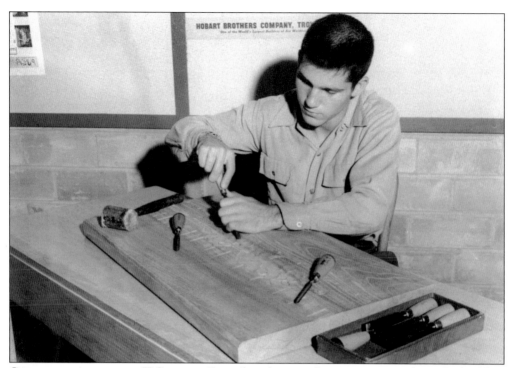

CONSTRUCTION OF THE Y-CHAPEL. Central students took a very active role in the building of the Y-Chapel. All of the furniture was made in the industrial arts department by students. Merle Keyser, a Bartlesville farmer, is pictured here doing the carving work for one of the pews. (Special Collections/Archives, University of Central Oklahoma Library.)

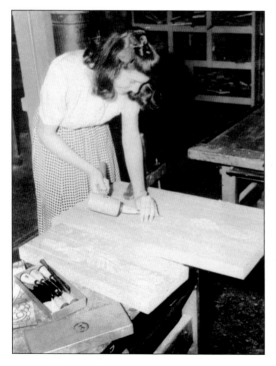

STUDENTS AT WORK. Gertrude Freed is pictured above working on a slab for a pew end pattern. Students carved all pew ends and chancel furniture. In addition, the low interior walls of the chapel were covered with tile, tan in color, on which the art students applied a pattern of crosses made up of simple lines broken by winged halos. (Special Collections/ Archives, University of Central Oklahoma Library.)

Y-CHAPEL CONSTRUCTION. A construction truck is pictured in front of the almost complete Y-Chapel of Song building. Construction was completed about the middle of April 1949. The chapel is an "L" shaped building which measures 56 by 56 feet. The total height is 22 feet. The sanctuary, which is 26 feet wide, has a seating capacity of about 125. (Special Collections/ Archives, University of Central Oklahoma Library.)

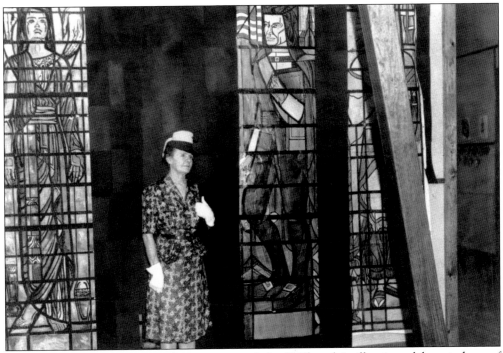

STAINED GLASS WINDOWS. The sanctuary of the Y-Chapel is illuminated by windows of stained glass, which were designed and executed by art students of the college to illustrate songs of the "Y" daily worship services. Ann Thatcher Hisel is pictured standing by the "America the Beautiful" window dedicated in honor of her father, Richard Thatcher. (Special Collections/ Archives, University of Central Oklahoma Library.)

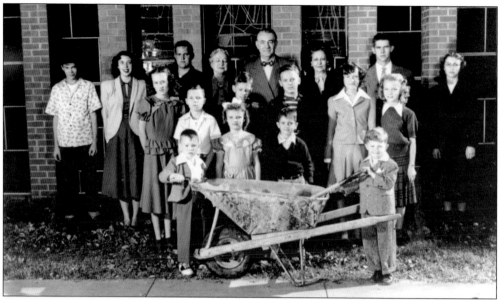

TIME CAPSULE. As part of Central State's Golden Anniversary Celebration, a time capsule was packed on homecoming day in 1941. The capsule was officially sealed at 11:30 a.m. on November 23, 1949, in a concrete crypt in the southwest corner of the Y-Chapel. Due to their age, students of the Demonstration School were chosen to seal the capsule because they "were more likely to be around fifty years later for the opening." (Special Collections/Archives, University of Central Oklahoma Library.)

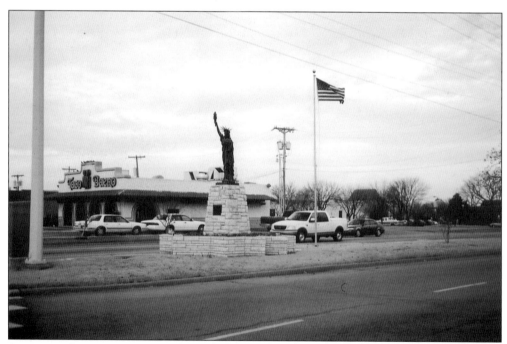

STATUE OF LIBERTY. On February 11, 1951, Edmond's own replica of the Statue of Liberty was unveiled at the intersection of Second and Boulevard. City officials and the Boy Scouts helped dedicate the statue. The statue had been won with a war bond drive. (Photograph by Author.)

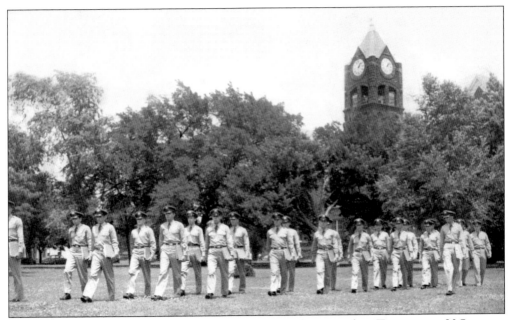

KOREA AND VIETNAM. Edmond again braced for war when President Truman sent U.S. troops to enforce the United Nations' demand to North Korea to stop their attack on South Korea in 1950. Just as that conflict ended in 1953, another one began in Vietnam in 1955. American troops would be in Vietnam until 1975. Pictured above are Air Force clerical students in front of Old North. (Special Collections/Archives, University of Central Oklahoma Library.)

OKLAHOMA CHRISTIAN UNIVERSITY. Central Christian College (CCC) first opened its doors in Bartlesville, Oklahoma, in 1950. In 1958, CCC relocated to two hundred acres of land, halfway between Edmond's far south side and Oklahoma City's far north side, at 2501 East Memorial Road. With the move came a name change to Oklahoma Christian College. By 1990, the college attained university status and became Oklahoma Christian University of Science and Arts. (Photograph by John Wilcox.)

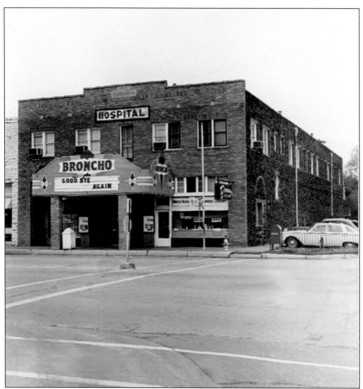

BRONCHO THEATER AND EDMOND HOSPITAL. This odd combination was housed inside the Spearman Building at One South Broadway. The two-story building was constructed in 1935-36 and was owned by W.Z. Spearman, who made the first floor the Broncho Theater. Dr. N. Wynn, Dr. D. Fleetwood, M. Baggerly, C. Kirkland, and R. McCoy founded the hospital in 1947. The Spearman Building made the best location because of its size. (Special Collections/Archives, University of Central Oklahoma Library.)

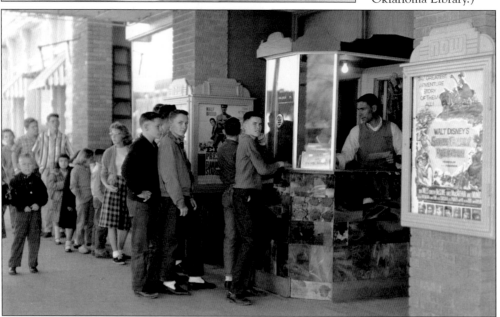

BRONCHO THEATER. The Broncho Theater officially opened in 1936. *Gone with the Wind* was the first big feature to be shown. W.Z. Spearman's son Crawford Spearman Sr. ran the theater after his father's death in 1938. The theater was eventually sold to R.R. McCoy and continued to operate through the 1970s. The building currently houses Othello's Restaurant. (Special Collections/Archives, University of Central Oklahoma Library.)

BAGGERELY FUNERAL HOME. Morey Baggerely first came to Edmond in 1910. He farmed and operated a hardware store for a number of years. He was even the town deputy sheriff from 1923 to 1927. He also helped organize the Campfire Girls in Edmond. He established the Baggerely Funeral Home in 1929. He died in 1965, but the business he founded now operates at three different locations. (Special Collections/Archives, University of Central Oklahoma Library.)

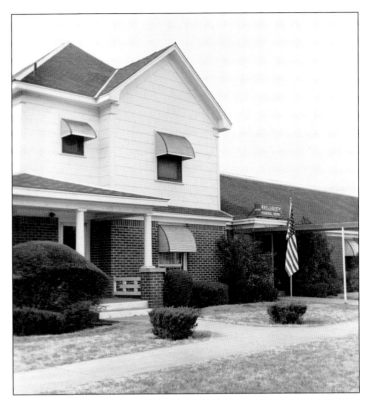

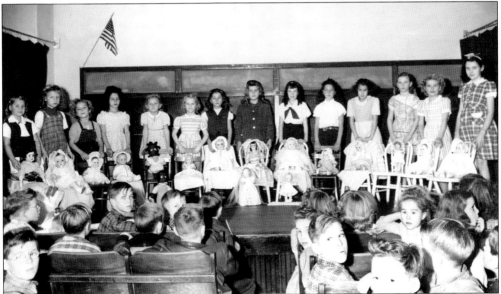

CAMPFIRE GIRLS. During 1947, the Edmond Campfire Girls improved their campsite, taught nine girls to swim, and even financed all their own activities by selling doughnuts. By 1948, with 150 girls registered, donut sales were not going to be enough. The organization began soliciting funds to cover all their activities. This 1948 picture shows some of the Campfire Girls during a doll show. (Linda Jones Collection, Special Collections/Archives, University of Central Oklahoma Library.)

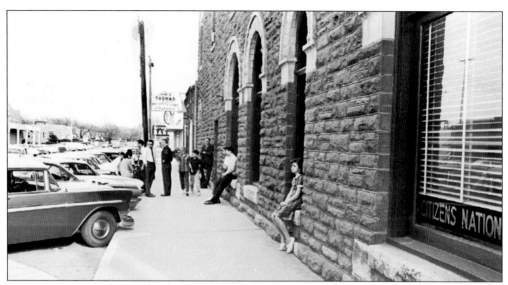

CITIZENS BANK OF EDMOND. Citizens Bank first opened its doors in 1901 at the corner of First and Broadway. Over the years, prominent Edmondites including E.A. Bender, G.H. Fink, W.J. Huffman, and Elmer E. Griffin have been associated with the bank. The most common factor, however, has been the Granzow family. H.W. Granzow started there in 1909. He was followed by his son Gordon Granzow and finally the current Chairman of the Board, Randy Granzow. (Special Collections/Archives, University of Central Oklahoma Library.)

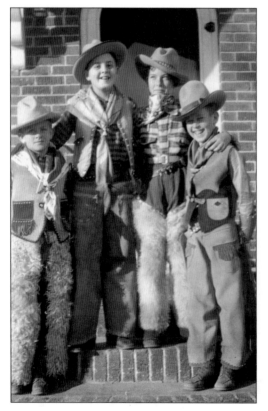

COWBOYS. This is a 1930s picture taken at the Granzow house. From left to right are Tom Flesher, Bobby Van Antwerp, Junior Keeney, and Gordon Granzow. While the Granzow family was busy running Citizen's Bank, the Van Antwerp's were running the successful Van's Bakery. George Van Antwerp, along with his brother Irvin, opened the bakery in 1915. Van's Bakery operated in Edmond for 44 years. (Linda Jones Collection, Special Collections/ Archives, University of Central Oklahoma Library.)

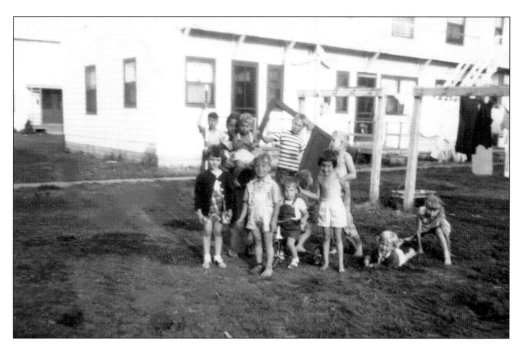

CENTRALVILLE. In 1947, Central State set up a temporary barracks on the campus to serve as housing for married veterans. The barracks were appropriately called "Centralville." The above picture was taken in 1951 and shows children in Centralville looking east-southeast. The picture below was taken in 1952 on the Christmas family's back porch. Sitting on the porch steps are the Christmas children, Dorothy and Stanley. (Stanley Christmas Collection, Special Collections/Archives, University of Central Oklahoma Library.)

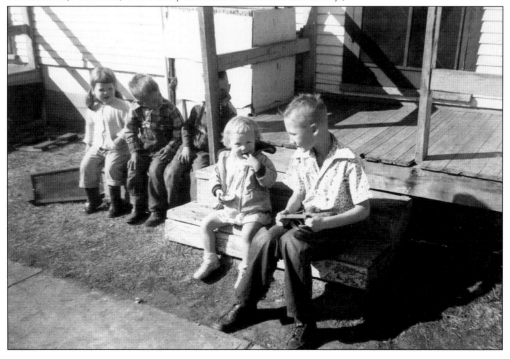

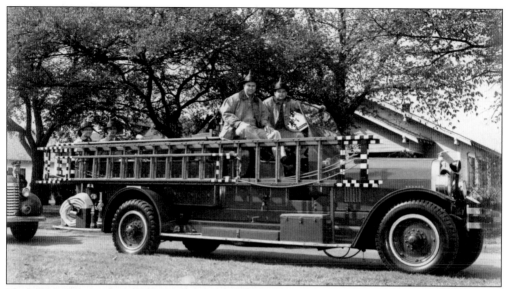

NEW FIRE TRUCK. In an effort to keep up with the rising population, the city purchased a new fire truck in 1953 for $17,205. Four firefighters gladly pose with the new vehicle in this 1954 photograph. (Linda Jones Collection, Special Collections/Archives, University of Central Oklahoma Library.)

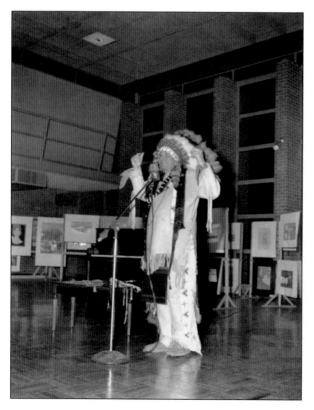

ACEE BLUE EAGLE. Acee Blue Eagle (che bon Ah-bee-la) was a prolific artist from Oklahoma. In the 1930s, he was commissioned by the government to paint murals throughout the state as part of the Project of Works of Art program. In 1934, he painted murals on the wall of Central's auditorium, Mitchell Hall. He is pictured above speaking to the American Association of University Women in 1958. (Special Collections/ Archives, University of Central Oklahoma Library.)

JENNIE FORSTER. The Forster's came to Edmond one month after the April 1889 Land Run. Jennie Forster immediately set out to serve her new community with vigor. She was an organizing member of the first Presbyterian Church, the first president of the Ladies' Aid Society, and Edmond's first librarian. After 70 years of service to Edmond, Forster passed away in 1959. (Courtesy of Lucille Warrick and Janie Bates, Special Collections/ Archives, University of Central Oklahoma Library.)

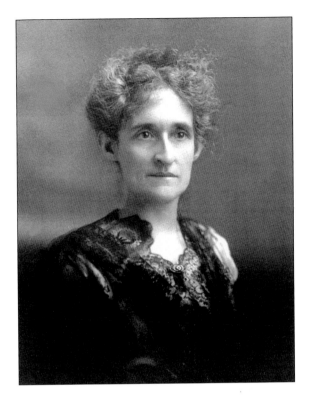

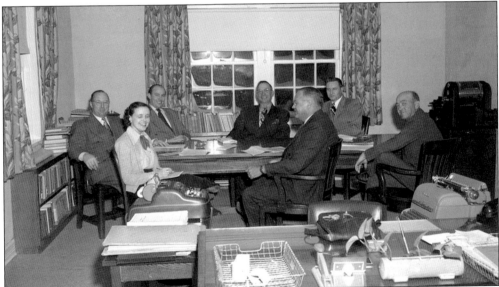

EDMOND SCHOOL BOARD. Edmond School Board members meeting to discuss district issues, from left to right, are as follows: (front row) Betty Barnett, Fred Kirkland, and Orvis Risner; (back row) Dr. Merle Glasgow, Bob Rice, Neal Fisher, and Merle McKee. A major issue before most of Edmond's school boards has been the city's rapid growth. By 1950, Edmond had four schools for grades K-12: Russell Dougherty, Clegern, Ida Freeman, and Edmond High School. (Linda Jones Collection, Special Collections/Archives, University of Central Oklahoma Library.)

DR. MAX CHAMBERS. The athletic Chambers graduated from Central in 1914, and went on serve as CSC's 15th president from 1949 to 1960. The Student Union, Fine Arts building and Max Chambers Library were all added during his tenure. In addition, new and enlarged parking lots were required to accommodate the school's all time enrollment high of 4,316 students. (Special Collections/Archives, University of Central Oklahoma Library.)

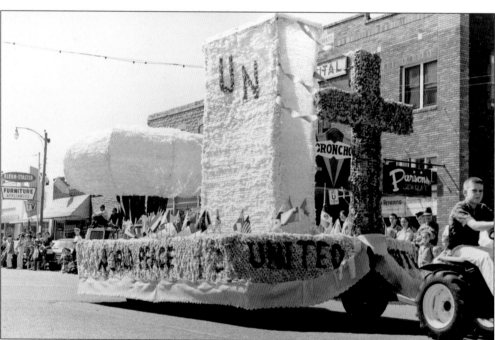

HOMECOMING PARADE. The photograph above was taken on September 5, 1963. The United Nations homecoming float can be seen traveling slowly down Broadway. The Broncho Theater and Hospital can be seen in the background. (Special Collections/Archives, University of Central Oklahoma Library.)

PRESIDENTIAL ELECTION OF 1960. In 1960, Vice President Richard M. Nixon battled Senator John F. Kennedy for the presidency. The Kennedy campaign made its way through Edmond with the help of several campaign posters and these eager Central students. The students were among the minority of Edmondites who voted for Kennedy. Nonetheless, Kennedy won the election with 303 electoral votes to Nixon's 219. (Special Collections/Archives, University of Central Oklahoma Library.)

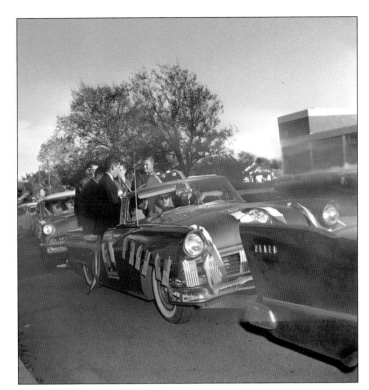

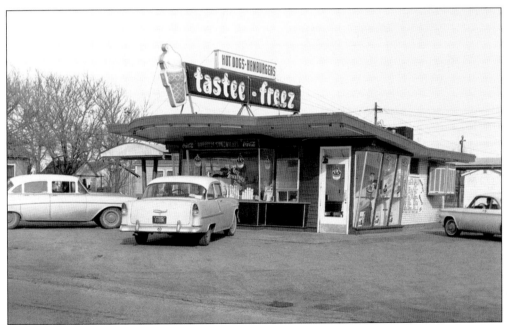

TASTEE FREEZ. In the 1960s, cafés like Royce and Wide-a-Wake were being replaced by a new kind of eatery—the drive-in. This 1961 photograph is of the Tastee Freez at 820 South Broadway. The Tastee Freez was not the only curb service restaurant in town, and its competition included the Broncho and Sonic. (Special Collections/Archives, University of Central Oklahoma Library.)

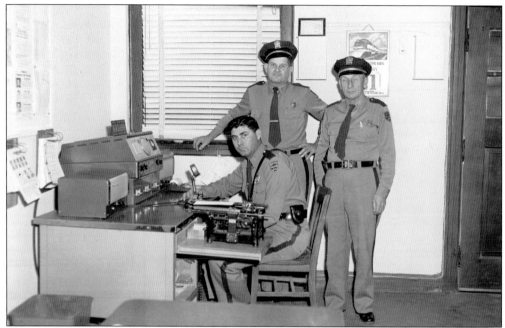

EDMOND POLICE. In this photograph three Edmond policeman pose by the station's dispatch radio. More police would soon be needed just to deal with traffic, because Edmond was literally on the edge of a population explosion. The days of two-lane main roads and limited traffic lights were about to end. (Special Collections/Archives, University of Central Oklahoma Library.)

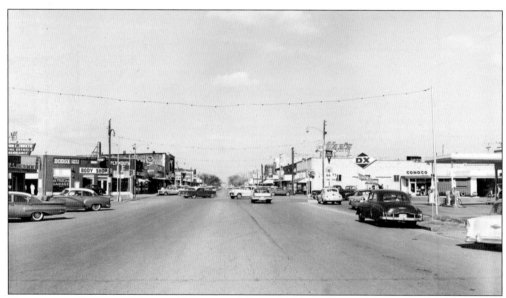

DOWNTOWN EDMOND. This is a 1961 view of downtown Edmond facing north. The intersection of Second and Broadway is visible with the Van's Bakery on the east corner and the Reynolds Plymouth Garage on the west corner. After a steady loss in business, the Oklahoma Railway Company discontinued the trolley system and in 1946 the Interurban tracks were removed from Broadway. (Special Collections/Archives, University of Central Oklahoma Library.)

POST OFFICE. On January 29, 1938, the Edmond post office building opened at First and Littler. A mural of Oklahoma wildlife, which was painted by Ila McAfee Turner on the walls of the lobby, greeted visitors to the post office. The picture above shows what the post office looked like in 1961. (Special Collections/Archives, University of Central Oklahoma Library.)

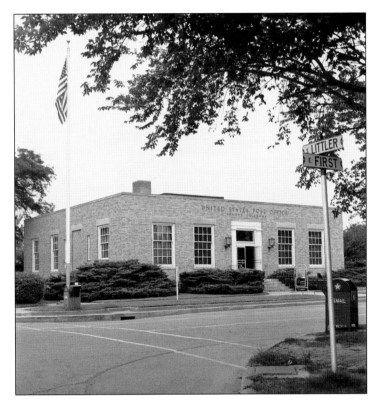

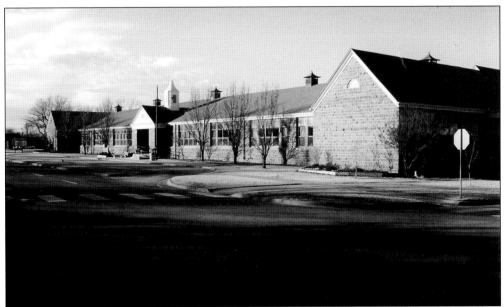

JUNIOR HIGH THEN ELEMENTARY SCHOOL. The Russell Dougherty School was dedicated on October 12, 1947. The school's namesake was the first Edmond High School graduate to loose his life while serving his country during World War II. The Kingsley, or East Side School, which opened in 1900, was demolished in 1946 to make room for the new school. (Photograph by John Wilcox.)

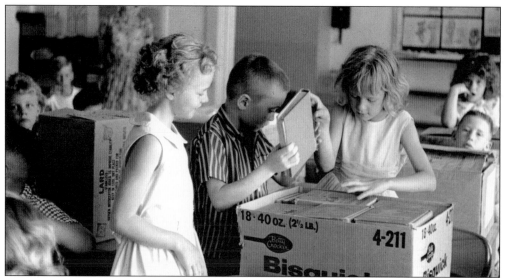

TRAINING SCHOOL CLOSES. The training school operated on the campus of Central State from 1901 until 1962. The training school was a very important addition to the college over the years. The first hand experience teachers in training received was invaluable. This photograph shows elementary students packing up books for the last time. The Campus School officially closed on May 27, 1962. (Special Collections/Archives, University of Central Oklahoma Library.)

NEW HIGH SCHOOL BUILDING. The need for a new high school had become apparent, and construction was completed in 1956. The old high school building on Boulevard became the junior high building. Yet another new high school building was built in 1974, at 1000 East Fifteenth (present site of Edmond Memorial High School), and the old high school building became Central Mid-High. (Special Collections/Archives, University of Central Oklahoma Library.)

COMMUNITY CENTER. Seeing a definite need, Mrs. Crawford Spearman, President of the Federation of Women's clubs, fought hard for a community center and the government through the WPA took notice. The government loaned Edmond $16,000 of the $20,000 that was needed to build the structure. The cornerstone was laid on March 30, 1936. In 1972, the Community Center, located at 25 West Third, became the Edmond Senior Center. The above picture was taken on May 5, 1961, and shows a driver that was a bit overzealous in his parking. (Special Collections/Archives, University of Central Oklahoma Library.)

SONIC DRIVE-IN. In 1953, Troy Smith of Shawnee could not have realized the success that awaited him with the opening of a small root beer stand. The stand had speakers so you could order from you car, and carhops who brought you your food. By 1967, the concept had really taken off and 41 Sonic franchises were operating in Oklahoma. In this photograph, students "hang out" at the Edmond Sonic in 1961. (Special Collections/Archives, University of Central Oklahoma Library.)

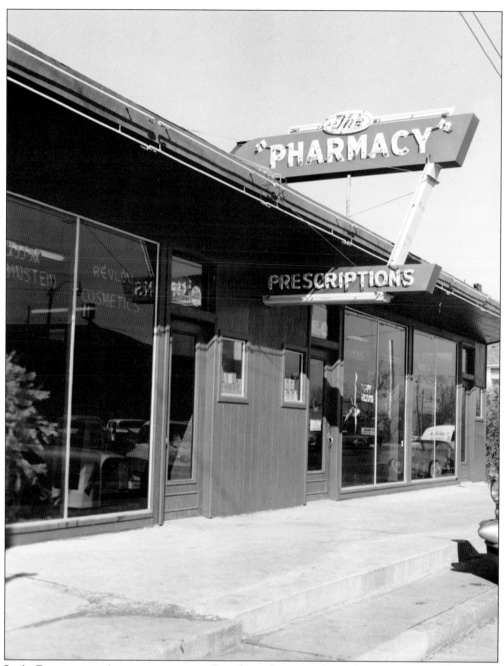

JIM'S PHARMACY. A common site on Broadway for a number of years was Jim's Pharmacy, located at One North Broadway. Pharmacists Jim Hargrove and Jerry Petzold ran the establishment. Another Jim's eventually opened at 1415 S. Boulevard. Jim's major competitors were Kirkland's Drug Center and Barrett Drug. (Special Collections/Archives, University of Central Oklahoma Library.)

BOULEVARD SUPER MARKET. As Edmond's population grew, so too did the need for more grocery stores. This 1961 photograph was taken at the checkout counter in the Boulevard Supermarket. The supermarket was located at 507 South Boulevard. The former tenant of this building was the Boulevard IGA. (Special Collections/Archives, University of Central Oklahoma Library.)

MADELINE'S FLOWER SHOP. This is a 1960s interior view of Madeline's Flower Shop. In 1950, Rex and Madeline Graham purchased J. Doyal Nicholson's Florist and Nursery at 1030 South Broadway. The name was appropriately changed to Madeline's, and the flower shop is still in business today at the same location. Barbara Bilke, Madeline's daughter, now owns the store. (Special Collections/ Archives, University of Central Oklahoma Library.)

VARIETY STORE. TG&Y (named for founders Thomlinson, Gosselin and Young) was a prominent variety store chain that headquartered in Oklahoma City. Edmond's first TG&Y opened in 1951 at Broadway and First. Another followed in 1963 at 1600 South Broadway, and yet another in 1966 at the Plaza Shopping Center. TG&Y's flourished for many years, but eventually dwindled to only a few stores nationwide in the late 1980s. (Special Collections/Archives, University of Central Oklahoma Library.)

RED BUD GROCERY. By 1962, Reed & Snyder's Second Street Market had been converted to the Red Bud Grocery Store. The original Red Bud was located at 22 East Second. In need of an upgrade, the new Red Bud Grocery opened in 1976 at 122 East Second. The above picture of the Red Bud was taken in 1962. (Special Collections/Archives, University of Central Oklahoma Library.)

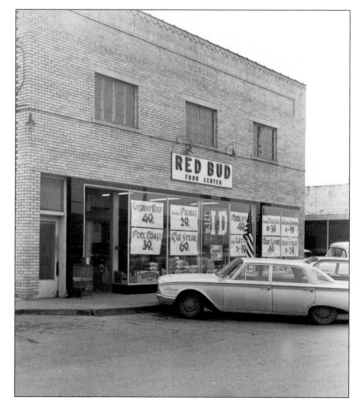

Four

1964–1989

The previous era of 1938–1963 left Edmond with a growth rate just over 100%. The next period in the city's history, 1964–1989, showed an almost unbelievable growth rate of just over 530%. Obviously, the face of Edmond radically changed during this period. Streets were widened, streetlights were added, and more and more businesses came to Edmond as a construction boom of colossal proportions took place. By 1985, Edmond was a city of 94 square miles with a population of 46,000. Edmond had ten elementary schools, four secondary schools, and nine parks that covered 170 acres. Early Edmondites would have been amazed by the changing face of their city as Edmond celebrated its 100th birthday in 1989. Local news that made national headlines consisted of the tragedy of the Edmond post office massacre, the 1986 tornado that ripped through the Fairfield addition, and the PGA Championship that was held at the Oak Tree Country Club in 1988.

Major events of the era, which affected Edmond, included the Vietnam War, the assassinations of Robert Kennedy, Dr. Martin Luther King Jr., and Malcolm X, the Civil Rights movement, the Equal Rights Amendment, the Iran hostage crisis, the energy crisis, and the fall of the Berlin Wall.

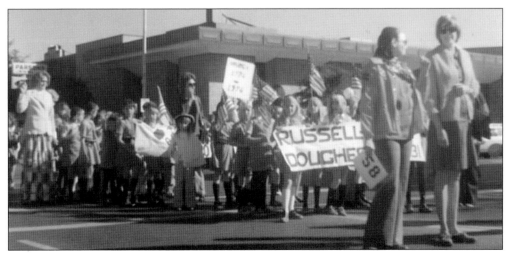

AMERICA'S BICENTENNIAL. 1976 marked the country's bicentennial, and an amazing rush of patriotism encompassed Edmond's annual Fourth of July parade. In addition to the parade, Edmondites enjoyed a rodeo and stunning fireworks display. Brownies and Girl Scouts are pictured above marching down Broadway during the parade. (Courtesy of Amy Mattingly.)

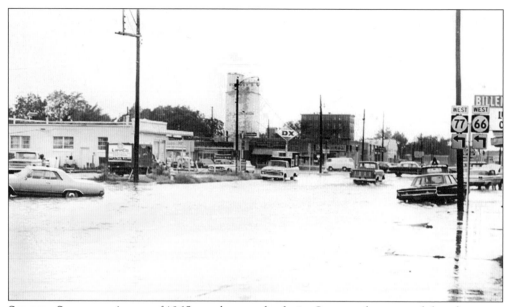

SUMMER SHOWERS. August of 1965 was the month of rain. Summer showers and thunderstorms caused power losses and flooding, as depicted in this picture taken on August 31, 1965. At that time the total amount of rainfall peaked at 25.5 inches for the year. One Saturday evening saw 1.8 inches of rainfall in under an hour. (Special Collections/Archives, University of Central Oklahoma Library.)

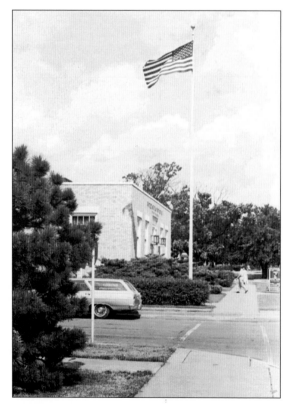

CITY HALL. Edmond's newly remolded City Hall reopened for business in March of 1965. The new annex was a ten-year dream of City Manager J.B. Marshall. The additions included drive-in window service for utility payments and a large council chamber. Most residents liked the new building, but there were those who were less than impressed. One man told the Edmond Sun, "It looks like a glorified chili parlor." (Special Collections/ Archives, University of Central Oklahoma Library.)

SEAL OF EDMOND. In 1965, the City of Edmond held a contest for a city seal design. Frances Bryan entered two drawings that went on to win First place and Third place. A new city seal was adopted by combining her two designs. The seal signified the merging of the railroad and the oil industries with the city's religious history, which combined with the land run and Central State College formed the backbone of Edmond—as seen in the four quadrants and handshake in the center. The seal gained some notoriety in the 1990s and almost became a case before the Supreme Court. Rev. Wayne Robinson asked the city to remove the cross in 1992. The City of Edmond refused and in January 1993, the ACLU stepped in and filed a lawsuit against the city claiming the cross was a violation of the First Amendment. After two years of legal battling the Tenth District Court of Appeals ruled in favor of the ACLU and the cross was removed. (Frances Bryan Collection, Special Collections/Archives, University of Central Oklahoma Library.)

NEW ELEMENTARY SCHOOL. Orvis Risner Elementary, named for the recently deceased president of the school board, opened in 1962. This photograph, taken on March 23, 1963, shows principal Harp and Boy Scouts John Steinman and Steve Evans planting a shelterbelt of redbud trees at the school. (Special Collections/Archives, University of Central Oklahoma Library.)

NORTHERN HILLS ELEMENTARY. The construction of Northern Hills Elementary, located at 901 East Wayne, was completed in 1964. The six-classroom grade school that would serve the northeast sector of Edmond was built for $140,000. (Special Collections/Archives, University of Central Oklahoma Library.)

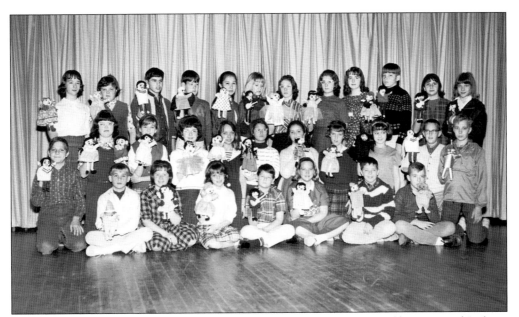

CLEGERN ELEMENTARY. Harry W. Clegern donated land just south of Fifth Street and Jackson for a new elementary school. Clegern School, named in his honor, opened its doors in 1928. The Clegern students pictured above are participating in a puppet show held in March of 1965. (Special Collections/Archives, University of Central Oklahoma Library.)

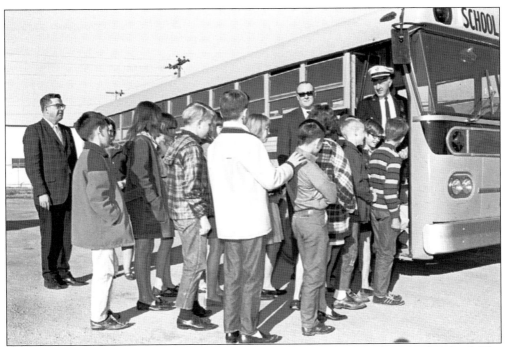

IDA FREEMAN SCHOOL. A new school was needed in 1950 to replace the Lowell School. The name was suitably chosen to honor Lowell's principal of 26 years, Ida Freeman. The above picture was taken on February 2, 1968, and shows several of the elementary school's junior police "on the job." (Special Collections/Archives, University of Central Oklahoma Library.)

JUNIOR HIGH CHEERLEADERS. The Edmond Junior High cheerleaders are pictured above on July 19, 1965. The girls attended the University of Oklahoma's clinic with 500 other participants. In the competition, Edmond won four first-place honors and one second-place honor. The squad included, from left to right; Debbie Davis, Marsha Brown, Lynn Kitzmiller, Kay Coyner, Vicki Tippins, Cindy Brown, Nancy Martin, and Debbie Bishard. (Special Collections/Archives, University of Central Oklahoma Library.)

HIGH SCHOOL FOOTBALL. The high school football season of 1965 started out strong but faltered when six Edmond players incurred injuries during the game against Star Spencer. The Bulldogs, under the guidance of Coach Fred Trenary, struggled through the rest of the season. The picture above is a September game against Del City. (Special Collections/Archives, University of Central Oklahoma Library.)

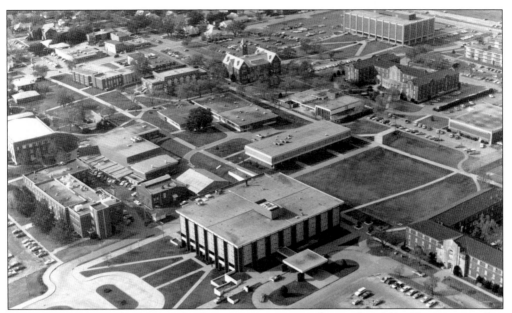

1967 AERIAL. Growth continued to be a major news story during the 1960s. However, another news story made national headlines in 1966. Part-time Central student Mary Lou Hood was charged by five of her neighbors with indecent exposure for mowing her lawn in a black bikini. Judge Bob Rudkin dismissed the case and Hood received a brand new mower from the G.W. Davis Corporation in New York. (Special Collections/Archives, University of Central Oklahoma Library.)

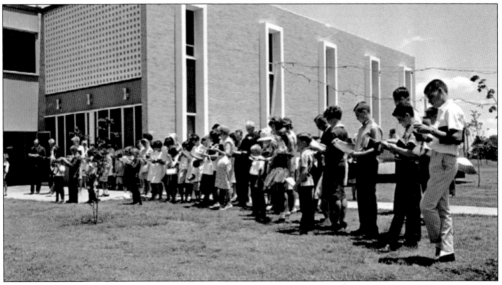

HENDERSON HILLS. Real estate developer C.A. Henderson purchased the section of land southeast of Fifteenth and south of Boulevard in 1957. More and more houses were needed and Henderson hoped newcomers would choose to live in the Henderson Hills addition. The above photograph, taken on May 10, 1966, is the groundbreaking of Henderson Hills Baptist Church at 2300 South Boulevard. (Special Collections/Archives, University of Central Oklahoma Library.)

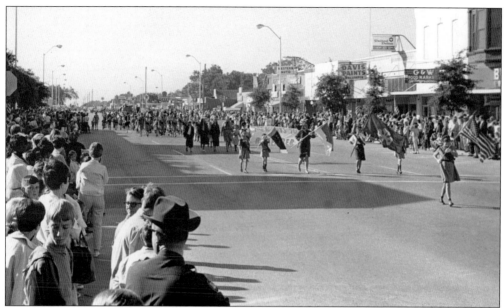

HOMECOMING 1968. Central State College held its annual homecoming parade on October 18. Around 10,000 students and residents flocked downtown to watch the procession. Several floats won prizes, including Sigma Kappa sororities Freedom Bell Float and the Physics and Math Department's Sir Isaac Newton Float, complete with a constantly falling apple. (Special Collections/Archives, University of Central Oklahoma Library.)

DEMONSTRATION. A mostly African-American contingent of students staged a peaceful demonstration on April 9, 1968, in honor of the slain Martin Luther King Jr. The demonstration started at the administration building where one student proclaimed, "The king is dead. That leaves 1,999,999 of us to fight for freedom." By 1969, Central State had three African-American organizations: the Afro-American Student Union, Kappa Alpha Psi, and Alpha Kappa Alpha. (Special Collections/Archives, University of Central Oklahoma Library.)

THE OLD ROUND BARN. The Arcadia round barn was built in 1898. The huge roof measures 60 feet in diameter. The barn was a landmark on Route 66, but years of disuse eventually took a toll and the barn began to deteriorate, as shown in this 1966 photograph. Carpenter Luther Robinson along with several volunteers took an interest and restored the barn in 1988. (Frances Bryan Collection, Special Collections/Archives, University of Central Oklahoma Library.)

MCCALLS. Morris "Hoot" Gibson opened the McCall's Men Store, located at 21 South Broadway, in 1953. By the early 1960s business was booming and a ladies department was added to the store. This picture, taken on October 31, 1967, shows the McCall's Men Store sweepstakes winner Deirel Sadler and his wife inside the store. The current owner is Morris Gibson's son, Steve. (Special Collections/Archives, University of Central Oklahoma Library.)

C.H. Spearman Jr. Two generations of Spearmans had already left their mark on Edmond, so it seemed more than appropriate that the third generation would do the same. While at Central State in 1949, Crawford Spearman won both the local and the state American Legion Oratorical Contests. He was also head of the Student Council. He went on to the University of Oklahoma's Law School and a career in the Oklahoma State House of Representatives. What he is best known for, however, is his dedication in the pursuit of getting Central State College changed to Central State University. Several unsuccessful attempts (one in 1967 passed both the House and Senate, but stalled with a veto from Governor Bartlett) faded into memory once the bill passed in 1971. Spearman, who is now an attorney in Oklahoma City, also wrote an autobiography entitled *God Isn't Finished With Me*. (Linda Jones Collection, Special Collections/Archives, University of Central Oklahoma Library.)

NEW STREET LIGHTS. Flashing yellow lights were added at the corner of Second and Bryant on October 16, 1970. The intersection would eventually become a four-way stop. Outrage and concern over an accident that took two lives the previous Wednesday and the eleven other accidents that had occurred since that January solidified the need for a signalization system at this intersection. (Special Collections/Archives, University of Central Oklahoma Library.)

EDMOND LIFE. This picture shows Edmond High School students at their desks in 1973. That same year the school board dismissed their superintendent, Hugh Bingham. Tom Acres and Gaylon Stacy resigned from the school board in protest. The next year, Edmond resident Karen Silkwood complained about the dangerous health and working conditions at Kerr-McGee Nuclear Corporation's facility in Oklahoma. Her complaint eventually led to a federal investigation. (Special Collections/Archives, University of Central Oklahoma Library.)

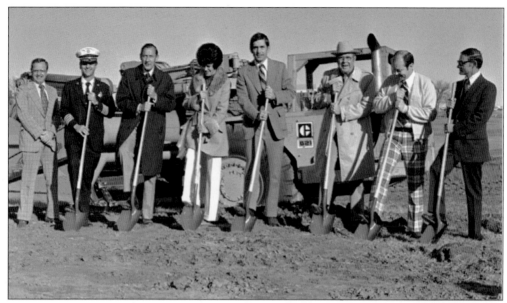

NEW FIRE STATION. This picture was taken November 13, 1975, during the groundbreaking ceremonies for the new Edmond fire station at Second and Baumann. The land was donated by Central State. Seen here posing at the ceremonies, from left to right, are Jack Nusbaum, Fire Chief Elmo Thornbrue, CSU President Bill Lillard, Norma Whelan, Harry Woods, Alvin Alcorn, J.C. Swanson, and Mayor Pro Tem Bill Stearns. (Special Collections/Archives, University of Central Oklahoma Library.)

ALLISON BROWN. This picture, taken in 1978, shows local Brownies receiving pins. The recipient is my sister and the girl enthusiastically waiting to the right is Allison Brown. Brown went on to win the Miss Teen Oklahoma pageant in 1985. She progressed to the Miss Teen USA pageant and won that, too, in 1986. (Courtesy of Amy Mattingly.)

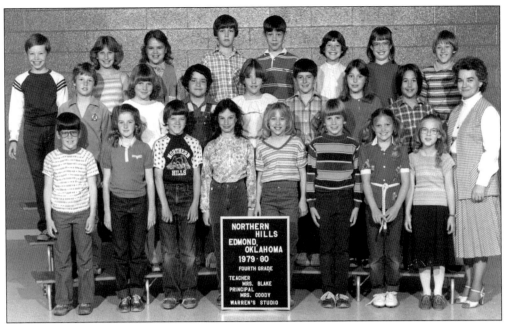

CLASS PHOTO. Edmond's reputation as a friendly community with outstanding housing developments and good schools bought more and more families to the area in the 1970s. In 1979 alone, an amazing 1,800 families relocate to Edmond. My family came to Edmond in 1973. This is a picture of my fourth grade class with our teacher, Mrs. Blake. (Courtesy of Amy Mattingly.)

DOWNTOWN 1979. In 1979, the energy crisis and unemployment were two of the top national news stories. Edmond felt the crisis with an increase in gas prices. However, unemployment did not seem to be a problem. Over two hundred new businesses came to town in 1979. Amidst all the rapid growth downtown managed to maintain its small town charm. (Frances Bryan Collection, Special Collections/Archives, University of Central Oklahoma Library.)

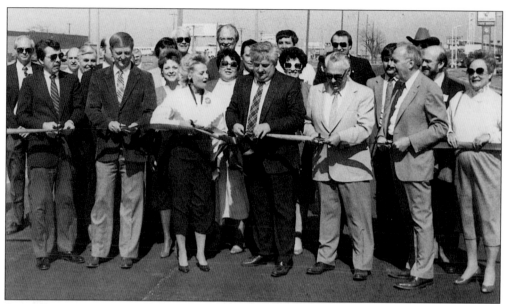

CARL REHERMAN. Carl Reherman (center) was the mayor of Edmond from 1979 to 1989. During his time in office, Edmond gained a new administration building, police station, and two fire stations. He also helped to bring international business to the city, complete Arcadia Lake, and widen several streets. Reherman and the city council also founded the Edmond Historic Trust in 1982. (Edmond Historical Society Photographic Collection.)

FARMER'S GRAIN COMPANY. Farmer's Grain Company, located at 102 West First, has been a part of Edmond for over 75 years. The Suenrams, starting with August Suenram, own the store. Emiel Suenram came to Edmond in 1901, and he was the grain company's manager for 41 years. One of his sons, Clifford, was also the director for many years. Clifford's brother, Charles, now minds the store. (Frances Bryan Collection, Special Collections/Archives, University of Central Oklahoma Library.)

2ND STREET UNDERPASS.
As Edmond grew, traffic
problems began to
escalate. The Santa Fe
four-lane underpass was
approved for West Second
Street in September
of 1967. Obviously,
businesses in the area
would be affected by the
new right-of-way. The
two major businesses,
Eagle Milling and Buell
Lumber, closed down.
Don Rodkey auctioned
off the last of the Eagle
Mill's equipment in
March of 1970. (Frances
Bryan Collection, Special
Collections/Archives,
University of Central
Oklahoma Library.)

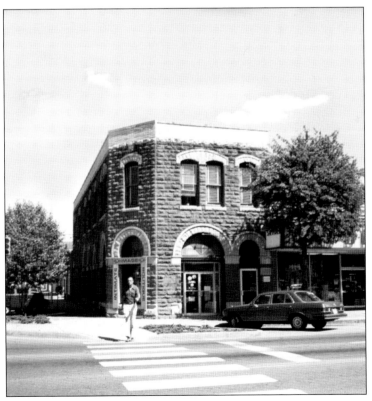

**SNYDER'S
HARDWARE.** The
long-time owner of
Snyder's Hardware was
Fred Snyder. Snyder
purchased the store
in 1953, when it was
called McMinimy
Hardware. He was
also the City Manager
from 1947 to 1950,
and Mayor from 1967
to 1973. Snyder's
Hardware, although
somewhat obstructed
by the tree, can be
seen to the right in
this 1981 photograph.
(Frances Bryan
Collection, Special
Collections/Archives,
University of Central
Oklahoma Library.)

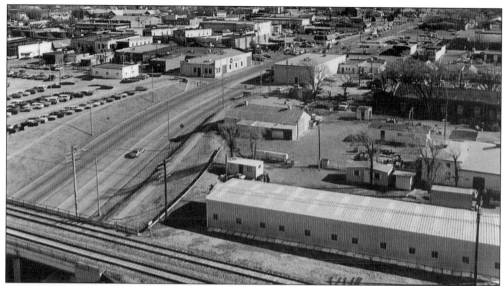

STILL GROWING. By 1980, Edmond was the second fastest growing city in Oklahoma. Over two hundred new businesses came to Edmond, and the population rose to almost 35,000. Incredibly, in 1982, 957 new homes were built. The progress is apparent in this aerial photo looking east from the Second Street underpass. The underpass was completed in 1971. The Edmond Sun building is the first building on the left. (Edmond Historical Society Photographic Collection.)

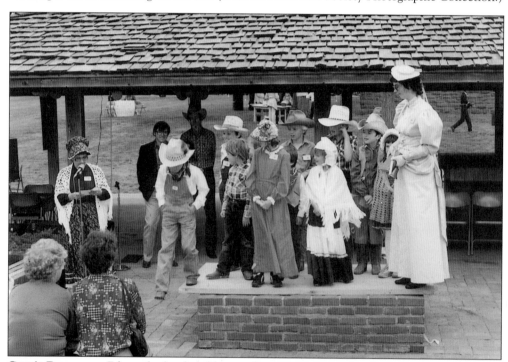

CITY'S BIRTHDAY. Edmond school children and citizens came to Stephenson Park to celebrate Edmond's 95th birthday in 1984. Throughout Oklahoma, "89er Day" is celebrated on April 22 with mock land runs. Betty Howell stands at the microphone to introduce the students and their teacher. (Edmond Historical Society Photographic Collection.)

POST OFFICE MASSACRE. Edmond's quiet tranquility was shattered just before 7:00 a.m. on August 20, 1986, when part-time postal carrier Patrick Sherrill reported to work with three handguns concealed in his mailbag. Without a word, he opened fire and killed 14 of his co-workers. Sherrill's rampage, which at the time was the third largest mass murder in United States history, finally ended when he turned the gun on himself. (Photograph by the Author.)

MEMORIAL. The Edmond Postal Memorial was dedicated on May 29, 1989, to honor and remember those who died: Betty Jarred, Patty Husband, Tom Shader, Rick Esser, Mike Rockne, Pat Gabbard, Jonna Gragart, Patti Welch, Judy Denney, Patty Chambers, Kenneth Morey, Bill Miller, Lee Phillips, and Jerry Pyle. (Photograph by the Author.)

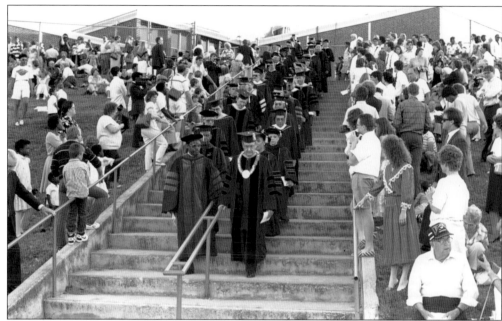

GRADUATION. The faculty of CSU enters Wantland Stadium during a 1980s graduation. President Bill Lillard (to the far right) came to Central State in 1975. During his 17-year tenure, the school was reorganized into four undergraduate colleges as well as the graduate college, three new buildings were added, enrollment increased to over 15,000, and in 1991 yet another name-change made CSU the University of Central Oklahoma (UCO). (Special Collections/Archives, University of Central Oklahoma Library.)

NEW BUSINESS–OLD BUILDING. By 1989, the Broncho Theater was long gone and the hospital had moved in 1967 to its own location at the corner of Second and Bryant. The building now housed Garfield's Restaurant. In 1981, Vince Orza Jr. started the Garfield's chain in Oklahoma. Orza went on to make two unsuccessful attempts to be the Republican candidate for governor in the 1990s. He may well make another attempt in 2002—this time as a Democrat. (Special Collections/Archives, University of Central Oklahoma Library.)

Five

1990–2001

By 1990, Edmond was a city of enormous homes, well-kept streets, booming businesses, and thriving community organizations. The school district, which was bursting in the 1980s, expanded to three high schools, four middle schools, and thirteen elementary schools. While Edmond continues to grow and expand, the downtown area retains its classic small town charm. The University of Central Oklahoma also continues to grow and change, but as one drives down University Street it is impossible to miss the Old North Tower still standing strong. As Edmond keeps on growing, there is little doubt that this once quiet and quaint little college town will continue along the path that has made it such a desirable location to live for over 110 years.

National and international news during the period of 1990–2001 include the Gulf War, the tragic and senseless bombing of the Alfred P. Murrah Federal Building in Oklahoma City by homegrown terrorists, the horrific September 11, 2001 terrorist attacks on America, and the resulting War on Terrorism.

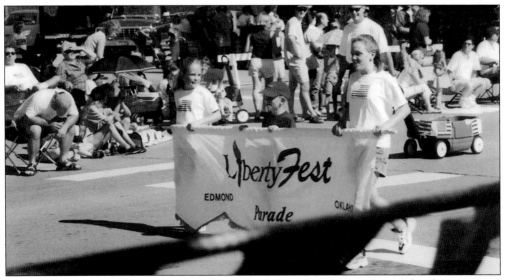

LIBERTYFEST 2001. Edmondites watch as the LibertyFest banner passes by their vantage point on Broadway during the Fourth of July parade. In just two months the nation and the world would be shocked and saddened by the terrorist attacks on the World Trade Center and Pentagon. (Edmond Historical Society Photographic Collection.)

EDMOND HOSPITAL. The hospital has undergone significant changes since first opening. The Hospital Corporation of America purchased the facility in 1980 and HealthTrust, Inc. purchased a major interest in 1987. Four stories had been added by the time Columbia Healthcare merged with HealthTrust, Inc. and Edmond became an HCA hospital. The hospital is now known as Edmond Regional Medical and employs over eight hundred physicians and employees. (Photograph by Author.)

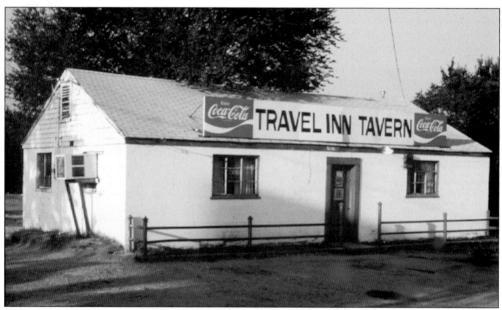

TRAVEL INN TAVERN. Throughout the 1930s–1950s travelers to Edmond on Route 66 passed by the Traveler's Inn and Travel Inn Tavern on Second Street. Route 66 followed this path through Edmond: one would enter at Second Street, go to Broadway, turn left on Memorial Road and take a right on Kelley out of Edmond. This picture, taken in 1984, shows the Tavern building before its eventual demolition. (Frances Bryan Collection, Special Collections/ Archives, University of Central Oklahoma Library.)

EDMOND LIBRARY. The Edmond Public Library finally opened its doors on January 14, 1967, in the Plaza Shopping Center. Genevieve Wise was the first librarian. The community had wanted its own library for a number of years. The actual library building (pictured above), located at Ten South Boulevard, was opened in 1972 and expanded and remodeled in 2000. (Courtesy of the City of Edmond.)

GEORGE NIGH. The University of Central Oklahoma gained a new president in July of 1992, George Nigh (5th from left). Nigh brought with him years of educational and political experience. He had taught at McAlester High School and had served as both lieutenant governor (1958, 1961, 1970, 1974) and governor (1979–1987) of Oklahoma. By 1994, over twenty projects of construction and remodeling had begun on campus. (Edmond Historical Society Photographic Collection.)

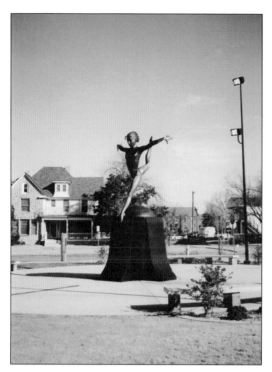

SHANNON MILLER. Former Edmond resident Shannon Miller has won more Olympic medals (two gold, two silver, and three bronze) and World Championship medals (nine) than any other United States gymnast—male or female. She won bronze and silver medals at the 1992 Olympics and two gold medals at the 1996 Olympics. This 18-foot bronze statue, dedicated in 2001, stands at First and Jackson in the Shannon Miller Park. (Photograph by Author.)

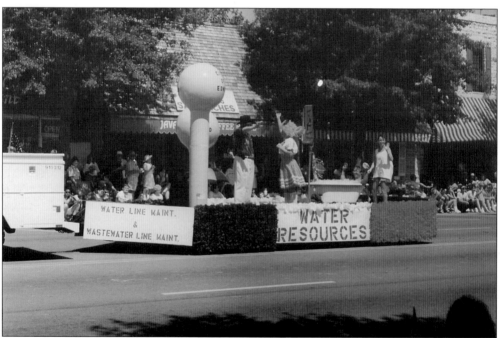

CITY FLOAT. The City of Edmond's Water and Wastewater Utilities float is pictured above during the 1996 LibertyFest parade. That same year UCO made national news when President Bill Clinton paid a visit to the campus and gave a speech to a crowd of over nine thousand. President George Bush Sr. had visited the campus of OCU in 1992. (Courtesy of the City of Edmond.)

CROSS. In 1996, MetroChurch asked the City if they could build a 157-foot cross at I-35 and Second Street. A flurry of debate for and against this proposal went on until approval was given to MetroChurch to build their cross with the stipulation that it not exceed 137 feet. The cross is pictured above. (Photograph by Author.)

CONTINUING CONSTRUCTION. With population exceeding 70,000 and new businesses continuing to open, construction is a big part of the scenery of Edmond these days. The southwest corner of Second and Bryant is gaining a new shopping and restaurant section. Long gone are the days when horses and carts brought wood; now, helicopters assist in construction. This is a photograph of the new Lowe's Home Improvement Warehouse being built. (Photograph by Author.)

SAUNDRA GRAGG NAIFEH. Edmond's first female mayor, Saundra Gragg Naifeh was elected to office on May 8, 2001, with 51.75% of the vote. The graduate of UCO's motto: "Embrace life, encourage excellence, and inspire hope." Naifeh, the 1982 Citizen of the Year, has a long record of community service. She has also been the Executive Director of the Oklahoma Association of Optometric Physicians for the past 12 years. (Courtesy of the City of Edmond.)

A GREAT PLACE TO GROW. By the 1990s, Edmond experienced an astounding growth rate. The population in 1990 was a reported 52,315 residents. The projected growth rate for 2000 was estimated at well over 72,000, or a 38% increase. Even with so many people wanting to relocate to Edmond the city maintains its small town charm, but with big city improvements which definitely make Edmond "A Great Place to Grow." (Photograph by the Author.)

OLD MEETS NEW. This 2001 photograph shows the old portion of the Normal School meeting the new part of the University of Central Oklahoma. Old North is clearly visible on the right side of the photograph. The building to the right is the new Education Classroom Building. (Photograph by the Author.)

ARCADIAN INN BED & BREAKFAST. This is Dr. Arthur Ruhl's home as it looks today. The inviting structure is kept in great condition by Gary and Martha Hall, who run the Arcadian Inn Bed & Breakfast. Their business received the honor of Oklahoma's number one choice for a bed & breakfast in the Oklahoman's 2000 Reader's Choice Awards. (Gary and Martha Hall Collection at the Arcadian Inn Bed & Breakfast.)

THE CATHOLIC PARISH OF ST. JOHN THE BAPTIST. St. John's bares no resemblance to the original one-room church that was built in 1889. Over time the parish grew and grew. The picture above is what the church looks like today. The grounds also include the St. Elizabeth Ann Seton School. (Photograph by Author.)

KICKINGBIRD ESTATES. The land that Milton "Kickingbird" Reynolds owned eventually became Reynolds Park. It was transformed into the Kickingbird Golf Course in 1971. The Kickingbird Tennis Courts were added in 1976. Kickingbird Estates was named because it was so close to the new recreational area. (Photograph by the Author.)

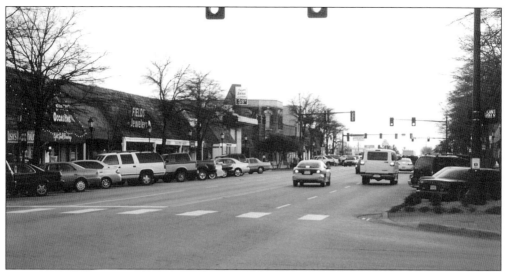

DOWNTOWN EDMOND. The past is still alive in the more than 90 retail shops, businesses and restaurants that are located in the downtown area. Downtown business includes Neal Little's Tag Agency, Parson's Jewelry, Around the Corner, The Styling Room, Othello's Italian Cuisine, and Citizen's Bank, to name only a few. Annual events put on by the Downtown Edmond Business Association (DEBA) include the Art's Festival, LibertyFest, Krazy Daze, and Trick or Treating. (Photograph by John Wilcox.)

FIRST PUBLIC SCHOOL HOUSE. The first public schoolhouse built in Oklahoma Territory still stands at 124 East Second in Edmond. The schoolhouse operated between 1889 and 1892. The building changed hands several times, and from 1950 to 1975 was the Sander's Camera Shop. On May 31, 2001, the Edmond Historic Trust purchased the building and intends to restore the landmark schoolhouse to its original form. (Photograph by John Wilcox.)

THE UNIVERSITY OF CENTRAL OKLAHOMA. For over 110 years Oklahoma's first institute of higher learning, now UCO, has been a part of the community. The university is the third largest in Oklahoma. The current president, W. Roger Webb, came to the school in 1997. The Special Collections and Archives (which were integral to this book) are housed on the second floor of the library. (Photograph by Author.)

THE RAILROAD. Although the Steen's pump house and the Edmond Depot have gone, the railroad that helped found this city remains. With operations in 28 states, the Burlington North Santa Fe is one of the largest rail networks in America. Even today one can watch the trains pass through Mile Marker 103. (Photograph by John Wilcox.)